**DATE DUE**

| DEC 0 6 2019 | | | |
|---|---|---|---|
| | | | |
| | | | |
| | | | |
| | | | |
| | | | |
| | | | |
| | | | |
| | | | |
| | | | |
| | | | |
| | | | |
| | | | |
| | | | |
| | | | |
| | | | |
| | | | |
| | | | |
| | | | |

Demco

D1441956

BRARY

83460-0405

# MODERN ART AND THE ROMANTIC VISION

**Deniz Tekiner**

University Press of America,® Inc.
Lanham • New York • Oxford

Copyright © 2000 by
**University Press of America,® Inc.**
4720 Boston Way
Lanham, Maryland 20706

12 Hid's Copse Rd.
Cumnor Hill, Oxford OX2 9JJ

**Library of Congress Cataloging-in-Publication Data**

Tekiner, Deniz.
Modern art and the romantic vision / Deniz Tekiner.
p.    cm.
Includes bibliographical references and index.
1. Romanticism in art. 2. Art, Modern—19th century. 3. Art, Modern—20th century 4.
Art and society—History—19th century. 5. Art and society—History—20th century. I.
Title.
N6465.R6T43   1999    709'.04—dc21    99—049085 CIP

ISBN 0-7618-1528-7 (cloth: alk. ppr.)
ISBN 0-7618-1529-5 (pbk: alk. ppr.)

To Roselle Tekiner

# Contents

# Preface

As a sociologist, I am intrigued by the espoused or implicit ideologies and the stated intentions of artists. Sociological studies of art, however, by their efforts to locate the bases of art in general social conditions which transcend individuals, tend to ignore these ideologies and intentions. Sociologists tend to view cultural life as a product of the exigencies of social systems, and generally pay little or no attention to the ideas of individual artists. Nevertheless, it is plain to me that the ideas of artists constitute an essential element of the ethos within which the activities of art worlds take place. Like other domains of social life, the art world is undergirded and animated by systems of values, or ideologies. Systems of values constitute the basis in meaning of social activity. In art worlds, artists and their intellectual prolocutors are principal architects of these systems. Because the ideas and concerns of artists arise in response to general social conditions, they are directly implicated in the dynamics of interaction between art and society. The ideas of artists, then, are pertinent to the sociological context of art. Sociological studies of art which fail to account for these ideas neglect the importance of artists as basic social constituents of art world activities. Because the ideas of artists often constitute forms of social criticism, these studies also neglect an essential aspect of the critical significance of art.

This book is principally an exposition of the confluences of modern art with Romantic ideas. But it is also a sociological study of the social concerns of artists and the responses of art to some general social problems. While it illustrates the presence of Romantic features in modern art, it also demonstrates the sociological relevance of the ideas and concerns of artists by showing the dynamic relation of these ideas and concerns to general social processes.

# Acknowledgments

I am grateful to the many colleagues and teachers who encouraged me as I developed the synthetic approach to the study of art which led to this book. Thanks are also due to my sister, Jeylan Mortimer, and my friends Seth Farber and Joanna Jasinska for their encouragement and support throughout the time that I worked on the manuscript.

# Introduction

The urge to be free is a basic impetus of social change. During the 18$^{th}$ century, the Enlightenment sought to finally quash the tyranny of religion and superstition over human thought and establish reason as the cornerstone of all human affairs. In France, the Revolution sought to overcome all political obstacles to freedom, destroying the ancien régime and forming a republican polity. The diverse literary and artistic movements which are now subsumed by the term "Romantic" emerged largely in response to some pernicious effects of the Enlightenment and the Revolution. The Enlightenment, proffering reason as the panacea for a new age, undermined human needs for spiritual feeling and expression. The Revolution, seeking to establish an ideal state by force, soon gave way to despotism and mass slaughter. In the views of many figures who are now known as Romantics, the Enlightenment and the Revolution were fundamentally flawed by their neglect of the human spirit, and the legacy of the "age of reason" was the disenchantment of the world. Processes of secularization, the ascendence of rationalism and scientism, and the exigencies of industrialization were depleting life of a sense of the sacred, and of wonder, mystery, and love. To ameliorate this condition, Romanticism sought to revitalize the spiritual life. Art was one of its principal means. Because art can stir the spirit, many Romantics regarded art as a salvific force for the modern world.

The various original manifestations of Romantic art faded away by the late 19$^{th}$ century. But some basic characteristics of Romanticism endured in several major art movements that followed. These features are found in French Symbolist art, early abstract art, Surrealism, Abstract Expressionism, and in earthwork art. Residual Romantic dispositions survive even in Pop art and in postmodernist art. Romantic concerns persist in much art today.

Since its publication in 1975, Robert Rosenblum's *Modern Painting and the Northern Romantic Tradition: Friedrich to Rothko* has remained the most substantive study of the Romantic foundations of modern art.[1] In the book, Rosenblum demonstrates some ideological and formal affinities between northern Romantic painting and several later art forms, showing that these genres share a mystical search for spiritual truth. The book covers significant ground, but the subject bears more attention. More recent studies are characterized by a circumscribed focus. The most extensive is *The Romantic Spirit in German Art 1790-1990*,[2] limited by its focus on German art alone. Studies of broader scope remain lacking. This book aims to help fill the gap by exploring Romantic features in a wide array of modern art forms, emphasizing the implications of the various genres in a critique of the disenchantment and the rationalization of the modern world.

This book employs several concepts of the German sociologist Max Weber. With the aid of Weber's concept of the ideal type, chapter 1 formulates a set of typical features of German Romanticism. Studies of Romanticism are often based on indistinct or vague notions of what Romanticism is. The ideal type which is presented provides a relatively exact framework by which to compare the characteristics of Romanticism with those of later art genres. Among the typical features discussed are the urge for a moral transformation of "heart" as exemplified by the concept of *Bildung* and the essentialist quest for a revelation of ideal forms, significant facets of German Romanticism which discussions of the movement often neglect. With the aid of Weber's concepts of value rationality and instrumental rationality, the chapter places the ideological aims of Romanticism in a sociological context. Weber's specific concepts of the disenchantment and the rationalization of modern life further facilitate a precise characterization of the social conditions against which Romanticism rebelled.

The remainder of this book explores the presence of Romantic features in an array of later art forms. In chapter 2, a discussion of essentialism demonstrates that the methods and aims of French Symbolist art are consistent with the Neoplatonic doctrines of Plotinus. The chapter also argues that the abstract art of Mondrian and Kandinsky was largely motivated by a philosophical dualism which called for a rejection of figurative representations of material nature. Chapter 3 considers various intellectual influences on Surrealism and Abstract Expressionism and also demonstrates that Carl Jung's concepts of the archetype, the collective

unconscious, psychic integration, and synchronicity are accurately reflected in the latter movement's non-figurative symbolism. Chapter 4 shows that Pop art, by its cynical representations of modern mass conformism, the superficiality of prevailing materialistic values, and the banality of popular culture, manifests an implicit Romantic critique of the rationalization of life. Pop art, however, evinces a postmodernist attitude which precludes any Romantic idealism. In chapters 5 and 6, discussions of earthworks and several contemporary artists show that some basic Romantic concerns remain vital in art today.

# Chapter 1
# What is Romanticism?

A systematic analysis of the Romantic characteristics of modern art obviously requires some understanding of what Romanticism is, and what the basic features of the movement are. Romanticism is a generic term that has long eluded a precise definition. Certainly no pithy set of words can fully apprehend the meaning of so complex a term, although many writers have tried. The problem of a definition is complicated by the various forms of Romanticism. Both German Romantic literature and painting plainly evince concerns with the disenchantment of the modern world as an existential problem. Such concerns are pronounced in the English poetry of William Wordsworth and William Blake, but are much less conspicuous in the English painting of the period. In French painting, Romanticism manifests mainly as an influence on the prevailing neoclassicism of the early nineteenth century, and hardly congealed as a distinct movement. Apart from Géricault and Delacroix, few if any French artists can be called Romantic without equivocation. The history paintings of several French artists such as Antoine Jean Gros, Carle Vernet, and Alexandre Gabriel Decamps have some Romantic qualities, but these works show little evidence of the spiritual and existential concerns which compelled the German Romantics.

Because of these complications, and because this book seeks specifically to examine the Romantic sources of spiritual-existential concerns in modern art, my discussion of Romanticism focuses on the German forms of the movement, including its *Sturm und Drang* precursor, in which these concerns appear unambiguously. My discussion is also illustrated with examples of some other forms of Romanticism in which these concerns are also plainly evident. Romanticism as a generic term may be too complex to be defined, but German Romanticism, at least, possesses some salient and recurring features which, delineated together, make up an

approximate explication of the movement. A description of these salient features follows. As is shown, these features constitute a critique of the disenchantment and the rationalization of the modern world, of the alienation of nature, and of the subordination of individuals to an emerging "collective mechanical life." They also comprise a prescription for ameliorating these conditions by evoking a heightened sense of spiritual realities and of connectedness to nature.

My explication of Romanticism in terms of its salient features is modeled after Max Weber's concept of the "ideal type."[1] Weber thought that the best way to come to grips with the meaning of a complex phenomenon is to delineate its principal components. This delineation is an ideal type. The ideal type is like an artist's caricature of a person in which outstanding features are highlighted and relatively insignificant features are played down or ignored. The result may be inexact but still presents a recognizable likeness. An ideal type does not describe a particular empirical phenomenon, but describes the typical features of a general class of phenomena. Weber's ideal type of bureaucracy, for example, does not describe any particular bureaucracy, but describes the typical features of bureaucracies in general.[2] All of the ideal typical features of a given phenomenon are not expected to be applicable to every manifestation of the phenomenon, some characteristics are more fundamental than others, and some are more recurrent. The ideal type is analogous to Plato's concept of the Idea or archetype, which is a thing in its universal essence abstracted from the temporal qualities of particular things. Likewise, the ideal type delineates the essential features of a thing abstracted from the distinctive constituent features of any particular thing. The following ideal typical features of German Romanticism are thus not applicable to every particular manifestation of the movement. They rather describe general features of the movement considered as a class. Although these features are most applicable to German Romanticism, they often appear in other forms of Romanticism as well. Weber intended the ideal type to be used as a model against which to compare particular empirical cases, enabling a researcher to see where the cases correspond to and differ from the model. Likewise, I follow my ideal type with analyses of an array of art genres, seeking to uncover where the genres do and do not correspond to the model.

I. Romanticism opposes the disenchantment of the modern world, or the general atrophy of human feelings of wonder, reverence, awe, and mystery. The concept of the disenchantment of the world is also best

understood with some help from Max Weber. In his various analyses of the development of Western societies, Weber observes that a process of disenchantment, which he identifies with a general enervation of the human affective faculties along with a degeneration of specific capacities for feelings of wonder and mystery, arose concurrently with the emergence of "instrumental rationality" as the dominant meaning-orientation of social action. Instrumental rationality is best summarized as the calculation of means to practical and utilitarian goals as ends in themselves. As instrumental rationality gains ascendence, the social importance of "value rationality" tends to be diminished. Value rationality seeks to realize and actualize abstract values such as divinity, truth, or moral goodness as ends in themselves. As Weber observes, value rationality tends to be the more preeminent meaning-orientation of social action in pre-modern or "traditional" societies. In the West it declined concurrently with processes of secularization, the growth of science and industry, and the progressive division of labor. Instrumental rationality undergirds the hallmark institutions of modern life—science, technology, industry, factory labor, bureaucracy, commerce, and the large state administration. Impelled by instrumental rationality, these institutions tend to subject people and nature to a cold calculation of utility.

The process of disenchantment is also concurrent with the rationalization of the world, a process, according to Weber, by which all human activities are progressively subject to more and more calculation and control by impersonal social forces. The rationalization of the world is the macro-level social outcome of the general ascendence of instrumental rationality. As the world becomes more rationalized, peoples' individual needs are increasingly subordinated to the collective imperatives of large organizations, social relations become more impersonal, and every aspect of life becomes more regimented. As rationalization proceeds, social life generally becomes more routine, monotonous, and mechanical. People are largely reduced to cogs in huge bureaucratic or industrial machines, devoting their lives to keeping a giant wheel turning. As Weber observes in *The Protestant Ethic and the Spirit of Capitalism*, the modern social world is becoming an "iron cage" of "mechanized petrifaction, embellished with a sort of convulsive self-importance," a world of "specialists without spirit, sensualists without heart; this nullity imagines that it has attained a level of civilization never before achieved."[3]

Weber's concepts of the disenchantment and the rationalization of the world have intellectual roots in the German Romantic critique of the

mechanization of modern life. Friedrich Schiller, a leading figure in the *Sturm und Drang* phase of pre-Romantic thought, observes in his 1793 *Letters on the Aesthetic Education of Man,* that modern society is becoming

> an ingenious piece of machinery, in which out of the botching together of a vast number of lifeless parts a collective mechanical life results. State and church, law and custom, were now torn asunder; enjoyment was separated from labor, means from ends, effort from reward. Eternally chained to only one single fragment of the whole, Man himself grew to be only a fragment; with the monotonous noise of the wheel he drives everlastingly in his ears, he never develops the harmony of his being, and instead of imprinting humanity upon his nature he becomes merely the imprint of his occupation, of his science.[4]

Schiller saw people turned to soulless cogs as they were progressively enslaved by utility. As he wrote, "Utility is the great idol of the age, to which all powers must do service and all talents swear allegiance."[5] As utilitarianism emerged as a basic principle of modern life, the individual was subsumed beneath a "collective mechanical life." In the *Letters,* Schiller attacks the progressive subordination of pursuits of abstract values such as truth or beauty to the principle of utility as a pernicious process of human mechanization. Thus Schiller turns an emblem of modernity—the machine—into an emblem of alienation, disenchantment, and social deterioration. In Schiller's view, modern people were recreating themselves in the image of their mechanical inventions. Sharing this view, Friedrich Schlegel, a founder of the Jena circle of German Romantic writers, wrote:

> The bourgeois man is first and foremost fashioned and turned into a machine. He is happy even if he has become only a number in a political sum, and he can be called in every respect perfect if he has transformed himself from a person into a cipher. As it is with the individual, so with the masses. They eat, marry, produce children, become old, and so on to infinity. Pure life simply for the sake of life is the source of baseness, and everything is base that has nothing of the world-spirit of philosophy and poetry.[6]

Likewise, presaging William Blake's reference to the "mills of Satan" in *Milton,* the Romantic poet Novalis, who was part of the Jena circle, attacked the Enlightenment's reduction of nature and the universe to a "self-grinding mill":

The result of the modern manner of thinking one called "philosophy," and regarded it as anything opposed to the old order, especially therefore as any whim contrary to religion. The original personal hatred against the Catholic faith gradually became a hatred of the Bible, and finally of all religion. Furthermore, the hatred of religion extended very naturally and consistently to all objects of enthusiasm, disparaging fantasy and feeling, morality and the love of art, the future and past. The new philosophy placed man of necessity at the top of the series of natural beings, and made the infinite creative music of the cosmos into the uniform clattering of a gigantic mill—a mill in itself driven by and swimming in the stream of chance, without architect or miller, a genuine *perpetuum mobile*, a self-grinding mill.[7]

Wariness toward machine technology and science is a basic theme of Romantic thought. In English Romantic literature, Mary Shelley's *Frankenstein* is the paradigmatic Romantic tale of scientific innovation run amok.[8] In her view as expressed in the story, science and technology are destined to far outpace human wisdom and become a force for the destruction of humanity. As Wordsworth also wrote in *The Tables Turned*:

Sweet is the lore which nature brings;
Our meddling intellect
Mis-shapes the beauteous forms of things:—
We murder to dissect.

The Romantic distrust of technology and science has taken root in the modern collective imagination and is a recurring theme of popular films. Fritz Lang's *Metropolis* (1927) envisions a totally dehumanized future in which the mass of people are enslaved in a technological underworld. In *Modern Times* (1936), Charlie Chaplin lampoons a worker's loss of self and sanity to life as a cog in the industrial wheel. As a tragic myth of modern life, the Frankenstein theme recurs in many films such as *The Fly* (1958), *2001: A Space Odyssey* (1968), *Blade Runner* (1982), and *Jurassic Park* (1993), to name just a few.

William Wordsworth's poem *The World Is Too Much with Us; Late and Soon* expresses a paradigmatic Romantic perspective on both the causes of and the remedy for the disenchantment of the world. In Wordsworth's view as expressed in this poem, worldliness and materialism have anesthetized modern people to spiritual experience. As an exemplary expression of "sentimental" Romantic longing, the poem seeks to recapture profound emotional responses before nature and divinity:

The world is too much with us; late and soon,
Getting and spending, we lay waste our powers:
Little we see in nature that is ours;
We have given our hearts away, a sordid boon!
This Sea that bares her bosom to the moon;
The winds that will be howling at all hours
And are up-gathered now like sleeping flowers;
For this, for everything, we are out of tune;
It moves us not—Great God! I'd rather be
A pagan suckled in a creed outworn;
So might I, standing on this pleasant lea,
Have glimpses that would make me less forlorn;
Have sight of Proteus rising from the sea;
Or hear old Triton blow his wreathed horn.

Evoking the sea gods of pagan mythology, Wordsworth evinces the Romantic notion that pagan religions exemplify authentic spirituality. This notion is also reinforced by Weber, who in his various studies of religion observes that magical practices and the mystical cultivation of direct experiences of the sacred are pronounced characteristics of primitive and ancient pagan religions, in contrast to the Western Jewish and Christian traditions which tend to be based primarily not in experience but in formal tenets of belief. While Romanticism exhibits nostalgia for ancient life, it generally does not seek to remodel contemporary life after the ancient world. It rather seeks ways to resurrect ancient sensibilities in modern forms. In the later terms of the French philosopher Lucien Levy-Bruhl, it seeks to recover a principle of "mystical participation" in modern life.[9] As Levy-Bruhl observed, Western rational thought tends toward division and separation, obviating the sense of the interconnectedness of humanity, nature, and divinity that many pre-modern peoples, whose capacities for subject-object distinctions are relatively undeveloped, take for granted. *The World Is Too Much with Us; Late and Soon* evinces the Romantic longing to recover an experience of mystical communion with nature and divinity.

Romanticism is associated with the notion that spirituality must be grounded in personal experiences of profound feeling, not in formal tenets of religious belief. Romanticism thus seeks to revitalize the affective dimensions of spiritual life while de-emphasizing or laying aside religious creeds. For example, the Romantic theologian Friedrich Schleiermacher, who was also part of the Jena circle, as deftly summarized by Robert Rosenblum, sought to "preserve the spiritual core of Christianity by

rejecting its outer rituals and by cultivating a private experience of piety that could extend to territories outside Christian dogma[,]...a kind of personal unbosoming of subjective responses before the mysteries of divinity."[10] The Romantic notion of an experiential religiosity can be traced to Jean-Jacques Rousseau's 1762 *Émile*,[11] in which the "Savoyard vicar" proposes a religion of "heart," requiring no scriptures, priests, or churches, in which God is experienced in a private contemplation of nature.

Accordingly, Romantic painting seeks to break free of the traditional symbols and themes which are associated with the tenets and creeds of religious belief. The German Romantic artists invented a language of symbols consisting of natural subjects which seeks to express and evoke personal experiences of divinity. By revealing the awe-inspiring possibilities of nature, and by investing nature with all the majesty of God, German Romantic art seeks to evoke an elemental feeling-experience of the *numen*, of divinity in itself, and thus to restore an experience of attunement to nature and the divine. In the words of the German Romantic painter Carl Gustav Carus, "When man, sensing the immense magnificence of nature, feels his own insignificance, and, feeling himself to be in God, enters into this infinity and abandons his individual existence, then his surrender is gain rather than loss."[12] Carus here describes the experience of finitude and absolute dependence before divinity that Schleiermacher identified as the essence of religion. The German Romantics sought to ignite such an experience, reinvigorating human capacities for profound feeling which are stifled by the utilitarian exigencies of a rationalized and disenchanted world.

II. To further its efforts to evoke numinous experiences of authentic spiritual feeling, Romantic art manifests the aesthetic of the sublime. The concept of the sublime originated in the Greek treatise *On the Sublime* which is attributed either to Dionysius Longinus of the 1st century or to the Neoplatonic philosopher Cassius Longinus of the 3rd century. The work distinguishes the sublime from the beautiful, pointing out that whereas beauty is pleasant by virtue of commonplace qualities of smallness, smoothness, and lightness, the sublime inspires awe by qualities of vastness, obscurity, and power. The concept entered modern intellectual discourses in 18th century English literary theory and criticism, most significantly in a series of essays by Joseph Addison written for *The Spectator* in 1711 and by Jonathan Richardson's *An Essay on the Whole Art of Criticism as it Relates to Painting* of 1719. The concept is central to Edmund Burke's *A Philosophical Enquiry into the Origin of our Ideas*

*of the Sublime and Beautiful* of 1757, a book which influenced the aesthetic philosophy of Immanuel Kant and the development of German Romantic thought. Kant's 1764 *Observations on the Feeling of the Beautiful and the Sublime* and his 1790 *Critique of Judgement* emphasize that the sublime is a capacity of human feeling rather than a quality inherent in phenomenal objects of perception.

According to Burke in *A Philosophical Enquiry*, the experience of the sublime is evoked by objects of terror which arouse the human instinct for self-preservation:

> Whatever is fitted in any sort to excite the ideas of pain, and danger, that is to say, whatever is in any sort terrible, or is conversant about terrible objects, or operates in a manner analogous to terror, is a source of the *sublime*; that is, it is productive of the strongest emotion which the mind is capable of feeling.[13]

The experience of the sublime, according to Burke, is one of "delight" in "the removal or diminution of pain"; objects of terror evoke no delight if they actually present a real danger. We can delight in these objects, however, when they are at a certain remove. As Burke wrote, "The passions connected with self-preservation...are delightful when we have an idea of pain or danger, without being actually in such circumstances."[14] When objects of terror are perceived to be both present and at a safe remove, then, we can delight in "astonishment"—"that state of the soul, in which all its motions are suspended, with some degree of horror."[15] Besides astonishment, these objects evoke "admiration," "reverence," and "respect." The attributes of objects of terror, according to Burke, are obscurity, power, privation, vastness, and infinity.

The German Romantic painters found that nature presents a wealth of such objects. Obscurity manifests in natural darkness, shadows, fog, and clouds. Power is in the extremes of natural phenomena such as towering mountains, deep ravines, cliffs, and the violence of storms and other natural upheavals. Privation manifests in situations of solitude, silence, and emptiness. Vastness and infinity are in the breadth of natural space. These objects evoke feelings of vulnerability before overwhelming forces and thus, in Schleiermacher's terms, evoke the essential religious feelings of human finitude and dependence. In works of art, these objects appear at once both present and, as images which present no actual danger, at a safe remove.

The German Romantic writer and critic Wilhelm Wackenroder, in his

1797 *Confessions from the Heart of an Art-Loving Friar*, observed that both nature and art, because they can express ineffable things, speak the language of God:

> ...I know of two wonderful languages through which the Creator has permitted human beings to perceive and to comprehend heavenly things in their full force, as far as this...is possible, namely, for mortal creatures. They enter into our souls through entirely different ways than through the aid of words; they move our entire being suddenly, in a wondrous manner, and they press their way into every nerve and every drop of blood which belongs to us. God alone speaks the first of these wonderful languages; the second is spoken only by a few Chosen Ones among men, whom He has anointed as His favorites. I mean: Nature and Art....
>
> Art is a language of a totally different type than Nature; but, through similar dark and mysterious ways, it also has a marvelous power over the heart of man. It...makes use of a hieroglyphic script, whose symbols we know and understand....But it fuses spiritual and supersensual qualities into the visible shapes in such a touching and admirable manner that, in response, our entire being and everything about us is stirred and affected deeply....
>
> The teachings of the philosophers set only our brains in motion, only the one half of our beings; but the two wonderful languages whose power I am proclaiming here affect our senses as well as our minds; or, rather..., they seem...to fuse all the parts of our nature...into one single new organ, which perceives and comprehends the heavenly miracles in this twofold way.[16]

The German Romantic painters discovered, in effect, that the "hieroglyphic script" referred to by Wackenroder can be expressed in a language of sublime natural images. Wackenroder admired traditional religious art, but the German Romantic painters sought more authentic and less tendentious forms of spiritual expression. In an aesthetic of the sublime based in natural imagery, Romantic artists found not only a non-canonic means of spiritual expression, but also a way to at once combine the expressive powers of both nature and art. Romantic landscape art, through the aesthetic of the sublime, expresses the immanence of God in nature, investing nature with all the power and majesty of God. The Romantic "symbolic landscape" evokes spiritual feeling-states through the psychological resonance of its images. Romantic art evokes these feeling-states without regression to the biblical motifs of traditional religious art such as the Annunciation, the Nativity, the Passion, the Resurrection, the Ascension, and so forth, with are bound up with Christian credos.

Romanticism thus presents spirituality as a matter of feeling and experience, not rational belief.

In the 1830s, as Romanticism was fading out in Europe, the movement was just taking hold in the United States, where it remained strong until the 1870s. The artists of the American Hudson River School truly mastered the genre. The aesthetic of the sublime is the most conspicuous Romantic feature of Hudson River School landscape painting. The hallmarks of the sublime landscape—towering mountains and trees, cliffs, deep crags and ravines, vast expanses, still or tempestuous waters, storms, ghostly or brilliant lights—are recurring features of Hudson River School landscapes.

III. Romanticism manifests a "sentimental" relation to nature. Friedrich Schiller's 1795 essay *Naive and Sentimental Poetry* contrasts two ways of experiencing nature. Evincing his idealization of classical antiquity, Schiller asserts that certain ancient peoples lived and felt at harmony with nature. Schiller calls this ancient experience of oneness with nature "naive." Modern people, however, because they have fallen from harmony with nature, experience nature as alienated and estranged. Schiller asserts that the sensual experience of the intrinsic beauty and harmony of nature, to the extent people can still experience it, can provoke people to become self-conscious of being estranged from nature, and in turn, also become self-conscious of being estranged from their own sensuality, their capacities to fully experience beauty. Further, the beauty of nature provokes an emotional longing to overcome these estrangements. Schiller calls this self-consciousness of estrangement and longing a "sentimental" experience of nature, an experience unique to modern people. As Schiller wrote, "Our feeling for nature is like the sick person's feeling for health."[17] Sentimental longing seeks to overcome the alienation of nature and, in effect, to recover a lost sense of mystical participation in nature's processes. Sentimental longing seeks the fulfillment of the human spirit in the re-enchantment of life.

For Schiller, nature is a perfect expression of beauty because it manifests the highest good, which is freedom. According to Schiller, nature is absolutely self-determined; he calls nature "freedom in appearance." In his view, nature manifests freedom because in nature reason and sensuality are perfectly harmonized. He calls this harmony the "spirit of play." In modern people, according to Schiller, the spirit of play tends to be deficient because the sensual faculties are subjugated by reason. In sentimental longing, the human spirit seeks to overcome the tyranny of reason and to harmonize itself with nature, realizing the freedom of nature in the spirit of

play.

According to Schiller, sentimental longing can be aroused by art as well as by nature. In his view, the artist is charged to evoke not only sentimental longing but also the resolution of sentimental longing in the spirit of play.[18] As he wrote, "The poet, I say, either *is* nature or he will *seek* it. The former makes for the naive poet, the latter for the sentimental poet."[19] According to Schiller, the aesthetic experience harmonizes the human "formal impulse," or reason, with the "sensual impulse," or sensuality, by evoking the "play impulse," or the spirit of play. In the spirit of play, the human spirit achieves harmony with the spirit of nature. In Schiller's view, the freedom of the human spirit is impossible while either the formal or the sensual impulses remain dominant. Sensuality unbalanced by reason is enslaved by bodily impulses, and reason unbalanced by sensuality is oppressed by moral compulsion. In the spirit of play, which manifests the freedom of nature, moral conduct is based not in compulsion but in free inclination. For Schiller, sentimental longing is resolved in the evocation of the spirit of play. Because the aesthetic experience evokes the spirit of play, it is a principal means toward the resolution of sentimental longing.

Sentimental longing is evinced in the Romantic aesthetic of the sublime, which seeks to evoke an experience of nature in its numinous essence as a manifestation of divinity. The aesthetic of the sublime in Romantic art is an expression of longing to overcome the alienation of nature in an experience of atonement. Eliciting experiences of the *numen* and of one's finitude and dependence before magnificent forces, the aesthetic of the sublime evokes feelings of the immanence of, and of connectedness to, nature and divinity, although these feelings tend to be tempered by the sense that a full experience of nature in its numinous grandeur is vaguely out of reach. The aesthetic of the sublime evokes the feelings of wonder, reverence, awe, and mystery before nature that Wordsworth, in *The World Is Too Much with Us; Late and Soon,* so yearned to recover. It thus holds forth the promise of the human atonement with nature and divinity, and the re-enchantment of the world, in the resolution of sentimental longing.

Enhancing the sense of sentimental longing, German Romantic art recurrently presents figures with their backs turned, standing or sitting, often before a vast landscape. Called the *Rückenfigur,* the turned figure is a familiar motif in the works of the German Romantic artist Caspar David Friedrich. The *Rückenfigur* functions to draw the viewer into the picture and thus to authenticate and enrich the sentimental experience. The *Rückenfigur* in effect summons the viewer to experience sentimental

longing vicariously through its point of view and enter into its contemplation.

Sentimental longing is also expressed in the recurrent Romantic themes of frustrated love or of yearning for an elusive ideal. It is central to Goethe's 1774 *Sorrows of Young Werther*, a tragic story of hopeless love, and in Novalis's unfinished novel *Heinrich von Ofterdingen*, about a young man's search to recover an experience of an ideal "blue flower" that he saw in a dream. Sentimental longing is also evinced in the Romantic idealization of distant cultures and nostalgia for bygone, allegedly more enchanted, ancient and medieval eras, which many Romantics believed manifested a greater harmony of humanity, nature, and divinity.

Sentimental  longing exemplifies the Romantic urge to reconcile estranged opposites—an essential religious impulse. The word religion, from its Latin roots, means "bind together again" from *re*, again, and *ligare*, to bind. In sentimental longing, the human spirit seeks self-realization in the atonement of opposites, a return to wholeness. Sentimental longing thus seeks to actualize the "archetype of return." The basic eschatological themes of many philosophies, from the pre-Socratics Heraclitus and Empedocles, to Plotinus and his followers, and on to Hegel's idealism, tell a story of the spirit's descent from a unitary source to which it inexorably returns. The mystical practices of many religions also seek the self-realization of the human spirit in a return to Godhead. Unlike the world-rejecting escapism of many mystical ideologies, however, Romanticism seeks to manifest spiritual self-realization not only in consciousness, but in the social world. As Wordsworth writes in *The Prelude*,

Not in Utopia, subterraneous Fields,
Or some secreted Island, Heaven knows where,
But in the very world which is the world
Of all of us, the place in which, in the end,
We find our happiness, or not at all.

IV. Romanticism seeks to evoke a moral transformation of the human "heart." The French Revolution demonstrated to the German Romantics that political programs alone are inadequate to the betterment of society. Even the best programs are bound to fail if the people who carry them through are morally misguided. In the Romantic view, people of good moral character are the requisite foundation of a good society.

No event had greater impact on the development of German Romantic

thought than the French Revolution. The Enlightenment celebrated reason as the basic principle of social and political life. Accordingly, the French Revolution sought to rebuild society on rational principles of liberty, equality, and fraternity. To the French revolutionaries, therefore, the violent overthrow of all traces of the ancien régime appeared to be a demand of reason. For the Jacobins, reason justified a brutal dictatorship and mass executions of political opponents in the Reign of Terror.

Many German intellectuals reacted with horror and disgust. The German Romantics generally regarded the French Revolution as fundamentally flawed by its attempt to transform society suddenly on the basis of abstract political principles. They valued the Revolution's principles of liberty, equality, and fraternity, but believed that these principles could be actualized only by a moral transformation of the character of individuals from within. Following Johann Gottfried Herder's historicism, they believed that a collective moral transformation must emerge gradually from the social ethos. Herder developed the view that societies are unique and generate their own principles of growth and change. Societies, in his view, grow like organisms and slowly adapt to their own changing circumstances. Romanticism thus became a defense of gradual, rather than sudden, social change.

The concept of *Bildung* is basic to the German Romantic belief that art can be an effective tool for the gradual moral transformation of society.[20] *Bildung* translates as "education" or "cultivation of character." For the German Romantics, *Bildung* must be accomplished by an appeal to the emotions. In the Romantic view, mere intellectual pedagogy is not a sufficient means to affect the human spirit. Because art and literature possess the capacities to be touching to the spirit and the emotions, they are essential to the process of *Bildung*. Accordingly, *Bildung* is implicated, for example, in the aesthetic of the sublime, which through its revitalization of religious feeling and its consecration of nature affects the moral disposition of the viewer.

Many of the German Romantics and their forerunners in the *Sturm und Drang* were early supporters of the French Revolution. Schiller, for example, during the 1780s, enthusiastically supported the basic ideals of the Revolution: opposition to the despotism of the ancien régime, freedom of thought, religious tolerance, equalitarianism, and the rule of law. After the Bastille was stormed in 1789, Schiller's position was changed. Horrified by the mob violence, he feared that the Revolution would degenerate into a barbaric ochlocracy. To preserve order, he opposed

overthrowing the monarchy. Like the French political philosopher Charles Montesquieu, he believed that a constitutional monarchy could coexist with a representative democracy. Schiller eventually came to the conclusion that the institution of a rational polity would require a moral transformation of spirits and minds. By 1793, when he published the *Letters*, Schiller believed that *Bildung* would have to be the principal form of revolutionary activity. *Bildung*, he believed, would be accomplished principally through aesthetic education.[21] For Schiller, *Bildung*, as the objective of aesthetic education, is exemplified in the harmonization of reason and sensuality. *Bildung* is thus fulfilled in the evocation of the spirit of play. As he reasoned, a civil society based on the revolutionary principles of liberty, equality, and fraternity would require its citizens to cooperate freely on the basis of natural inclination rather than moral compulsion. Aesthetic education, in his view, harmonizes the rational and sensual faculties, disposing people to act in accord with good moral conduct by inclination rather than compulsion. Aesthetic education, therefore, according to Schiller, is requisite to the success of revolutionary struggle.

Schiller's 1781 *The Robbers* expresses sympathy toward the idea of violent revolutionary struggle, tempered by wariness toward the abuses of power which could result. The protagonist, Karl Moor, leads a violent gang of robbers against the wealthy and oppressive aristocratic and clerical elite of German society. Like Robin Hood and his gang, Moor's gang robs from the rich to give to the poor. Moor hopes that his actions will destroy the corrupt foundations of German society and prepare the way for a republican order. But Moor witnesses rampant corruption among his own men and his hopes are dashed. A similar theme prevails in Schiller's 1782 *Verschwörung des Fiesco*, in which the revolutionary protagonist becomes just as tyrannical as the monarch he deposes.

In the 1780s, Schiller still did not foreclose the notion that a violent revolutionary rebellion might be justifiable. In his 1788 *Geschichte des Abfalls der Vereinigten Niederlande*, Schiller extols a 16th century revolt by the Dutch against Spanish despots. But this revolt was led by persons of the aristocracy and upper classes who, unlike the uneducated masses, in his view, had enough temperance to conduct themselves prudently. Schiller believed that the institution of freedom must be the principal motive of revolutionary struggle; a rational polity must provide a legal guarantee of freedom. In the wrong hands, however, a revolution can easily degenerate into a mercenary struggle for power and domination. He did not trust that uneducated or uncultivated people, people who did not have the benefits

of *Bildung*, could have virtuous revolutionary motives.

Whatever remaining sympathy Schiller felt for the French Revolution finally dissolved after the execution of Louis XVI in 1793. In Schiller's view one form of despotism had been replaced by a worse one. France succumbed to a savage mob. Schiller finally concluded that freedom could never be realized through violence, even if a perfect constitution were legally imposed. He insisted that the creation of a civil society based on reason would require a populace possessing moral virtue and wisdom. This could be achieved only through the cultivation of character, or *Bildung*, which must be achieved by means of aesthetic education. Because *Bildung* cannot be achieved rapidly, according to Schiller, progress toward a revolutionary society must be gradual. He also concluded that *Bildung* could remedy the moral shortcomings of the lower classes. He realized, however, that the lower classes are overwhelmed by the necessities of life and have no leisure time for cultivating character. As he wrote, "Today necessity is master, and bends a degraded humanity beneath its tyrannous yoke."[22] He believed that in a free polity, the lower classes must be relieved of their material burdens.[23]

Friedrich Schlegel agreed with Schiller about the importance of *Bildung*.[24] Schlegel believed that aesthetic education must be the major means of *Bildung*, because art and literature, by their appeal to the emotions, can foster the right inclinations which are the necessary foundation of a moral community. He believed that Romantic poetry must be a central aspect of *Bildung*. Like Schiller, Schlegel held that appeals to reason alone are inadequate. Neither are laws an adequate means of holding society together. A moral community, in Schlegel's view, must be held together by a common spirit of love; a spirit of fraternity is necessary to sustain liberty and equality. He believed that Romantic poetry could foster this spirit. In 1798 Schlegel founded the journal *Athenäum*, which he thought would spearhead a new process of *Bildung* and revolutionize German culture. The *Athenäum* constituted a manifesto of German Romanticism. Schlegel's brother August Wilhelm, Schleiermacher, Novalis, and Friedrich Schelling were among the journal's contributors.

Earlier, Schlegel championed neoclassicism and aestheticism. He believed that art's only proper function is the production of beauty. Ancient Greek poetry, in his view at the time, attained perfection because its concerns were limited to the domain of aesthetics. He believed that art tends to be adulterated when it is invested with extraneous concerns such as the good or the true, subjective feelings or opinions, or contemporary

problems. Because ancient Greek poetry did not exceed the appropriate boundaries of art, he thought, its beauty is objective, universal, and perennial. By 1795, as expressed in his essay *Ueber das Wert des Studiums der Griechen und Römer*, Schlegel began to abandon neoclassicism. Influenced by Herder's historicism, he came to appreciate the cultural specificity of the relevance of art. Cultural products of one age may have little or no substantive meaning for those of another. If art seeks to contribute meaningfully to the culture of its own time, therefore, it must express the spirit of its own time.

After reading Schiller's *Naive and Sentimental Poetry*, Schlegel began to appreciate the significance of artistic subjectivity. As Schiller pointed out, the sentimental poet expresses personal feelings in his or her longing to recover an alienated ideal. This longing, in turn, is an expression of the spirit of the sentimental poet's own age. Ancient Greek poetry, or neoclassical imitations of it, which are "naive," do not address the modern poet's problems—those of reconciling reason and sensuality, or of recovering the harmony of self, nature, and divinity. By the printing of the first edition of *Athenäum*, Schlegel championed the very ideas that he earlier condemned. He became a leading exponent of Romanticism, which is concerned not only with the beautiful, but also with the good and the true, the artist's feelings and opinions, and contemporary problems. Through these concerns, Schlegel and his colleagues thought, Romanticism would be capable of affecting the human spirit and actualizing a revolution of the heart.

The early writings of the German philosopher G.W.F. Hegel also express the Romantic urge to realize a revolution of the heart. The belief that moral law must be written on the heart, and the moral inadequacy of codified law, is a theme of Hegel's early theological essays. These essays express a Romantic maxim: If religion is to fulfill its moral purpose, it must be based in subjective feeling, not dogma or ecclesiastical authority.

The most important of these essays, Hegel's 1795 *The Positivity of the Christian Religion*, attacks Christianity as a "positive" religion, based in dogma, not virtuous subjectivity.[25] Christian dogmatics, in Hegel's view, contradict the original spirit of Jesus' teachings. These teachings, as Hegel observes in his 1795 essay *Life of Jesus*, exemplify Immanuel Kant's moral philosophy. Jesus' golden rule, for example, restates Kant's categorical imperative: "Act only so that the maxim of your action can be willed as a universal law." But Jesus, unlike Kant, sought to impress moral law on the spirit. His efforts failed, in Hegel's view. Christian morality is "objective";

it exists outside subjects, exercising its power through dogma, rules, and ecclesiastical authority. Hegel observed that Christian morality is based principally on coercion, not free inclination.

Hegel argues in these essays that Christian morality became coercive in the process of the institutionalization of the Christian religion. Jesus demonstrated by his own example, however, that moral rightness could be based on love, not reason. Oppositions of body and spirit, reason and passion, duty and inclination, individual and society, are harmonized, according to Hegel, in love. Through love, therefore, in Hegel's view as expressed in these essays, the kingdom of God could be actualized in the world. According to Hegel, then, the Christian religion could, if it were brought into accord with the original spirit of Jesus' teachings, bring about the revolution of the heart which is necessary to the actualization of an ideal polity.

V. As exemplified by the aesthetic of the sublime and the sentimental relation to nature, Romanticism idealizes nature. Romantics typically take the panentheistic view that God is immanent in nature, that nature is imbued with God. For panentheists, in contrast to pantheists, nature is not God but is in God; God is more than the sum of its material creation. In the Romantic view, the divinity of nature exceeds rational apprehension, but can be experienced in feeling. The natural human capacities for profound spiritual feeling, however, tend to be blunted and suppressed beneath the exigencies of modern rationalized life. Romantic art seeks to awaken these dormant spiritual capacities and elicit a revelation of nature as divine. The experience of nature as divine overcomes the alienation and objectification of nature as it is perceived from the ideological standpoint of instrumental reason as a mere object of utility. Perceived as divine, nature becomes an object of reverence and respect.

The Romantic idealization of nature, like the notion of a non-canonic religion of "heart," has an origin in Rousseau, who in his 1755 *Discourse on the Origins of Inequality* insists that human beings in their pre-civilized "state of nature" lived as "noble savages" but grew corrupt as civilization emerged. Rousseau in this respect opposes the views of the 17th century English philosopher Thomas Hobbes, who holds that human beings by their nature are insatiably concupiscent and violent, requiring forceful control by an all-powerful sovereign, or "Leviathan." In Rousseau's view, the original state of human nature was idyllic, characterized by social harmony and material plenitude. As social relations became more complex, property relations and social inequality ensued, initiating a spiral descent into

corruption. The civilized institutions of law, commerce, industry, science, and the arts, according to Rousseau, all lead humanity further from its original nobility. Rousseau's idealization of the original state of human nature prefigures the German Romantic notion that a good society must be based on the natural inclinations of people of good character, not the coercive rule of law; in Rousseau's state of nature, people are disposed toward the moral good by natural inclination. Rousseau's *Émile*, to mitigate against civilization's corrupting influences, proposes a process of childhood education which minimizes constraints and fosters, as much as possible, a child's natural tendencies. Rousseau's condemnation of the arts, along with the sciences, as a source of corruption, in his 1750 *Discourse on the Sciences and the Arts*, however, marks a departure from ideal typical Romantic thought.

VI. Romanticism tends, at least implicitly, to be essentialist in the Platonic sense. The movement is characterized by a belief in a basic ontological order of ideal forms, and seeks a revelation of these essential forms. In the metaphysics of Plato, Ideas are the blueprints by which the demiurge models the material universe. Phenomenal things are conceived as imperfect copies of these essential forms, or archetypes. In the metaphysics of Plotinus, the 3rd century originator of Neoplatonism, Ideas constitute the cosmic intelligence or *nous*, which is the first emanation of the One, the divine first principle of all things. As emanations of the *nous*, all perceptible things are patterned after their ideal forms. All material things, then, are conceived as ideal in their essence. For Plotinus, the revelation of things in their divine essence is the purpose of art. For Plotinus, beauty is the shining forth of the spiritual essence of a thing.

Essentialism is an implicit feature of German Romantic aesthetics. Although Platonic and Neoplatonic metaphysics were not explicit features of German Romantic thought in general, they were significant influences on Schelling, who was one of the foremost philosophers of the movement. Schelling believed, with essentialist overtones, that art can reveal absolute realities which exceed the scope of philosophical concepts. Schelling's philosophy of art had a profound effect on German Romanticism. As Tzvetan Todorov shows in *The Theory of the Symbol*, August Schlegel believed, under Schelling's influence, that symbols allow the infinite to appear in finite form, and Schlegel's concept of the symbol is basic to German Romantic aesthetics. As Schlegel wrote in 1801,

> According to Schelling, the infinite represented in finite fashion is beauty,

a definition in which the sublime is already included, as it should be. I am in full agreement on this point. I should simply prefer to formulate this expression as follows: the beautiful is a symbolic representation of the infinite; for in this way we also see clearly how the infinite can appear in the finite....How can the infinite be drawn to the surface, made to appear? Only symbolically, in images and signs....Making poetry...is nothing other than an eternal symbolizing.[26]

The notion that the divine essences of things, or "the infinite in the finite," in Schlegel's terms, can be expressed through symbolic forms is evinced in the Romantic aesthetic of the sublime, which through its language of symbols seeks to disclose phenomenal nature in its numinous essence. Consistent with Neoplatonism, Romanticism conceives of nature as an earthly manifestation of divinity. As the protagonist of Novalis's Heinrich von Ofterdingen remarks, "The higher world is nearer to us than we commonly think. We are already living in it here, and we perceive it as intimately interwoven with earthly nature."[27] While the German Romantic writers and artists did not typically frame their essentialism in explicit Platonic terms, essentialism is nevertheless a basic feature of the movement.

In A Philosophic Enquiry, Burke refers to Plato only twice in passing. However, the English Romantic poets later showed explicit interests in Neoplatonism. As Kathleen Raine shows in Blake and the New Age, Neoplatonism directly influenced the English Romanticism of Blake, Coleridge, and Shelley, and the American transcendentalism of Emerson and others, through the writings of Thomas Taylor.[28] Blake and the New England transcendentalists were also influenced by Emanuel Swedenborg's theory of correspondences which, like Neoplatonism, holds that material nature is replete with representations of divinity.

Essentialism was later an explicit aspect of Symbolist art, which sought with deliberate intention to manifest the Neoplatonic concept of beauty. Essentialism also influenced Carl Jung, who in turn influenced the American Abstract Expressionists. In Jung's psychological transposition of Neoplatonism, archetypes are conceived as constituents of the collective unconscious. In Jung's analysis, certain archetypes, as expressions of the collective unconscious, are represented in the art and myths of all cultures. Archetypal representations, in his view, by virtue of their intrinsic resonance with the collective unconscious, can elicit powerful emotional responses.

The cross is a quintessential archetypal representation. In their efforts

to bring the symbolic power of the cross to bear in landscape art, Romantic artists used natural and man-made objects as surrogates for the cross. Romantic landscapes constantly feature objects such as trees, pillars, mountains, and gothic buildings as axes which, like the cross, symbolically link earth to heaven, and humanity to God, and mediate these oppositions. Also recurrent are rainbows, which symbolize heavenly blessings and glory, and, like the cross, represent a bridge between earth and heaven. Many of Friedrich's works feature the masts of ships which, like the window panes of his *Fensterbild* works, reverberate the cruciform. Along with these surrogate images, many Romantic landscape paintings feature explicit Christian crosses, often in the form of grave markers, which further amplify the religious significance of the landscape.

Romantic art features other archetypal representations which are derived from constituents of the natural landscape. The sun, a symbol of almighty power and God itself, is a recurrent Romantic subject. Also recurrent is twilight, symbolic of mystery, passage into a new state of being, and spiritual rebirth. A very frequent motif is water, symbolic of the creative principle, the great mother, birth, purification, fertility, unconsciousness, and mystery.

VII. Romanticism seeks an authentic experience of self and free subjectivity. It seeks to actualize the self in a meaningful experience of life. Although Romanticism predates the formal advent of "existential philosophy," it grapples with the basic existential problems of alienation, authenticity, and loss of meaning. The Romantic is impelled by an inner necessity of spirit to solve these problems. Romanticism's efforts to recover an authentic, meaningful life require it to resist social pressures toward the repression of feelings, conformism, and surrender to the "collective mechanical life." Romanticism thus aspires to freedom of thought and feeling, or free subjectivity.

The problems of meaning and subjectivity are implicated in the view through a window, or *Fensterbild*, a frequent motif in German Romantic art.[29] Friedrich's *Woman at the Window* (1822), for example, combines the *Rückenfigur*, which holds similar symbolic connotations, with the *Fensterbild*. In *Fensterbild* works, a window frames only a small segment of landscape, viewed from inside a room. In these works, bright and sunny outdoor skies typically stand in contrast to the relative darkness of room interiors. Through the *Fensterbild*, Romantic art explores the relation between inside and outside, interior and exterior, subject and object, ideal and phenomenal, and thus symbolically deals with the problems of

subjectivity, alienation, and meaning.

From the Romantic standpoint, the modern individual faces three dimensions of alienation: first, alienation from the spiritual capacities of the self, or from the complete actualization of one's intrinsic natural capacities for subjective feeling-experiences, including religious or spiritual experiences, which are inhibited beneath the exigencies of a rationalized social world; second, alienation from nature, or from a sense of intimate connectedness to objective nature; third, alienation from society, or the social atomization of the modern individual which emerged with the development of rationalized *Gesellschaft* forms of society. The problem of Romantic alienation would be resolved in a meaningful experience of self, nature, and social life. A modern "enlightened" individual, being unconstrained by the traditional proscriptions of religious belief, is forced ultimately to confront the problem of meaning alone. The *Fensterbild* symbolizes such a confrontation. It exemplifies the Romantic longing for an authentic experience of oneself and one's relation to the external world.

The *Fensterbild* also exemplifies the Romantic use of everyday objects as religious symbols. *Fensterbild* works typically feature a window pane which forms a cross. In *Fensterbild* works, the subject's relation to the objective world is symbolically mediated by the archetypal cruciform. Presenting the cross in the indirect form of an everyday object, the cross is availed of its archetypal impact while evading the ideological associations which are intrinsic to explicit representations of the Christian cross. Abstracted from its formal religious context, the psychological effect it elicits is subliminal and unconscious, circumventing conscious processes of reason and intellect. The viewer of the work of art thus experiences the cross as an archetypal image, not as a church emblem.

The *Fensterbild* may be interpreted as a precursor to the grid motif in modern abstract art, as in the works of Mondrian, Kandinsky, and Klee, among many others. As Rosalind Krauss has observed, the grid in modern art is emblematic of the perennial human urge to come to terms with paradox and contradiction.[30] By its reverberation of the cruciform figure, an ancient symbol of redemption, the grid symbolically suspends the confusion inherent in the human confrontation with unreconciled oppositions. The Fensterbild holds the same symbolic implications. The Judaic Star of David, the Egyptian Ankh, and the Buddhist Wheel of the Law, like the Christian cross, also signify the harmonization of oppositions. The cross is the simplest and most minimal of these forms. Opposites are symbolically conjoined at the intersection of its vertical and horizontal

lines. The *Fensterbild*, by mediating the domains of subjectivity and objectivity through the cruciform, suggests the possibility of a resolution of the problems of alienation and meaning. Further, by abstracting the cross from its formal religious context, the *Fensterbild* confronts these problems in a secular context, independently of church tenets. Romantic art, as exemplified by the *Fensterbild*, confronts these problems inwardly, through the contemplation intrinsic to sentimental longing, and the communion with nature and divinity intrinsic to the experience of the sublime.

VIII. Romantics conceive of the artist as a genius, gifted with extraordinary sentient and creative powers, who feels and expresses things that others should but do not. The Romantic notion of artistic genius is an assertion of the uniqueness and spiritual integrity of the individual against the leveling and fragmentation of individuality beneath the utilitarian exigencies of the modern "collective mechanical life." Romantics conceive of art as the revelation of a pure heart. As Friedrich wrote,

> The heart is the only true source of art, the language of a pure, child-like soul....Every true work of art is conceived in a hallowed hour and born in a happy one, from an impulse in the artist's heart, often without his knowledge.[31]

Exemplifying the Romantic concept of the artist as genius, and of the salvific function of artistic genius, Novalis's Heinrich von Ofterdingen remarks that poets are "untrammeled visitors, whose golden feet make no sound and whose presence involuntarily unfolds wings in everyone."[32] The Romantic genius parallels the shaman of pre-modern cultures, who through dreams and visions communes with spirits and deities, and communicates his spiritual power and insights to others. The Romantic artist's special abilities to divine and communicate the language of God is evinced in the aesthetic of the sublime, which is a revelation of nature in its numinous essence.

By its revelation of divinity, Romantic art seeks to restore balance to a wayward world. Expressing a Romantic view of the redemptive function of art and of the artist as a specially gifted visionary, Carl Jung wrote, "When conscious life is characterized by one-sidedness and by a false attitude, then they [archetypes] are activated—one might say, 'instinctively'—and come to light in the dreams and the visions of artists and seers, thus restoring the psychic equilibrium of the epoch."[33] Accordingly, Romanticism seeks to invest the world with the light of its spiritual vision.

# Chapter 2
# French Symbolism and Early Abstract Art

In mid-nineteenth century Europe, Romanticism declined amidst a resurgence of enthusiasm for the prospects of reason, science, and industry. France led the way, giving rise to the zealous positivism of Saint-Simon and Comte. Both French Realism, which emerged in the 1840s, and French Impressionism, which arose in the 1870s, were consonant with the basic positivistic assumption that empirical data are the only valid basis of human knowledge. French Realism rejected idealized and metaphysical subject matter and emulated the principle of scientific objectivity. The French Impressionists, like the Romantics, often showed reverence for the beauty of nature, but were concerned above all with an exact analysis of visual perceptions and, disdaining the Romantic notion that art should excite the emotions, had no explicit interests in eliciting spiritual responses. During the 1840s and 1850s, concurrent with the Realist movement, a tempered Romanticism endured in the French Barbizon School, which shared the Romantic longing for renewed contact with nature but did not show the explicit spiritual and existential concerns which were distinctive of German Romanticism. The Pre-Raphaelite schools of nineteenth century England, by their interests in religious and natural subjects, had a certain Romantic temper. Unlike the German Romantic artists, and similar to the German Nazarenes, however, the Pre-Raphaelites sought not to invent a modern form of spiritual expression but to revive the religious and mythological subjects of medieval and early Renaissance art. Nevertheless, Pre-Raphaelitism's meticulous symbolism and bright colors influenced the development of Symbolist art, and the movement's fantastic and dreamlike imagery also prefigures Surrealist art. In America, from the 1820s to the mid 1870s, Romanticism thrived in the Hudson River School. By the late 1870s, naturalistic tendencies gained influence in the United States, and the Hudson River School also faded away.

Romantic attitudes reemerged forcefully during the late 1880s and the 1890s in French Symbolist art and in much of the work of its scion, the Nabis, which, like Romantic art, resisted the disenchantment of modern life and sought to awaken dormant spiritual responses through art. Originally a French literary movement, represented notably by the poets Stéphane Mallarmé, Paul Verlaine, Arthur Rimbaud, and Jean Moréas, the Symbolist writers sought to express subjective emotional experiences and ineffable transcendental realities through enigmatic images and metaphors. Based loosely on essentialist thought, literary Symbolism sought a symbolic means to communicate personal experiences of ideal realities. As Moréas wrote in the Symbolist Manifesto, published in *Le Figaro* on 18 September 1886, "Symbolic poetry seeks to clothe the Idea in a perceptible form."[1] The perceptible forms of Symbolism are Ideas "clothed" in symbols. Symbolism thus seeks to manifest a synthesis of ideal and perceptible forms. In the Symbolist visual arts, of course, the perceptible forms are visible.

Georges-Albert Aurier, who wrote for the *Mercure de France* and his own journal *Le Moderniste*, was the leading intellectual prolocutor of French Symbolist art. Although he died of typhoid at the young age of 27, he produced the most thorough articulation of Symbolist art theory that emerged from the movement. Aurier's Symbolist art theory synthesizes the philosophies of Plotinus, the 18th century Swedish mystic Emmanuel Swedenborg, and alchemy.[2]

In Plotinus's metaphysics, the Ideas or archetypes are constituents of the cosmic mind or *nous*—the first and most rarefied emanation of the divine first principle, the One. Matter is the last and the grossest emanation, but matter, mirroring the *nous*, consists everywhere of representations of the Ideas. Psyche, or Soul, is an intermediate emanation between *nous* and matter. All living things are souls, and as such partake in both the higher ideal and the lower material domains. Human souls, according to Plotinus, possess the capacities to direct their attention either upward to *nous* and the One or downward to matter. But most human souls, like the prisoners of Plato's cave, become absorbed in the realm of matter, see only "shadows," and have no knowledge of the Ideas. Plotinus asserts that contemplation of the spirit, the divine light, can bring a revelation of the Ideas, and ultimately, mystical union with the One.

Symbolist art seeks a revelation of the Ideas. Overcoming the intrinsic limitations of Realism, Impressionism, and all forms of naturalism, which seek to represent things only in their corporeal appearances, Symbolism

seeks to reveal things in their divine essences. Revealed in their essences, things, in turn, are symbolically sanctified. By its revelation of the Ideas, Symbolist art seeks to truly manifest the Neoplatonic concept of beauty —the shining forth of the spiritual essence of a thing.

Swedenborg's metaphysics bears obvious parallels with that of Plotinus. Like Plotinus, Swedenborg believes that nature is replete with representations of divinity. Swedenborg calls these representations "correspondences." As he wrote,

> There is a spiritual world, and also a natural world....Natural things represent spiritual things and...they correspond....What is natural cannot possibly come forth except from a cause prior to itself. Its cause is from what is spiritual....All things in the world present some idea of the Lord's kingdom, consequently of things celestial and spiritual....Natural things were created to clothe spiritual things as skin clothes the bodies of men and animals, as outer and inner barks clothe the trunks and branches of trees.[3]

Studying both Plotinus and Swedenborg, Aurier observed that Plotinus's concept of material nature is largely congruent with that of Swedenborg. For both philosophers, material nature consists everywhere of representations of spiritual essences. Aurier reasoned that if art could reveal the spiritual correspondences in nature as they are conceived by Swedenborg, the Platonic Ideas would also be revealed. The artist's symbolic representations of the correspondences would, as Moréas put it, "clothe the Idea in a perceptible form." As Aurier wrote, "The normal and final end of painting, as well as of the other arts, can never be the direct representation of objects. Its aim is to express Ideas, by translating them into a special language."[4] Doing this, the artist symbolically performs alchemy, the ancient mystical system which seeks to transmute base substances into refined substances. By revealing the spiritual essences of material nature, the artist symbolically transmutes material nature into divine forms.

Like the Romantics, Aurier was appalled by the disenchantment of modern life and believed that art could revitalize the human spiritual faculties. Aurier was especially offended by the positivistic assumptions, which had gained wide acceptance and seemed to be a pervasive aspect of the social ethos, that empirical data constitute the only valid basis of knowledge and that the highest potentials of humanity will be actualized by the progress of science and technology. According to the ideology of positivism, utility is the ultimate measure of value, and spiritual concerns

are of little or no use. Aurier lays much of the blame on positivism and the modern idolization of science for the atrophy of the spiritual life. In his view, owing to the spiritual inadequacy of positivism and scientism, a resurgence of metaphysical worldviews seemed inevitable and imminent. In his colorful prose,

> After having proclaimed the omnipotence of scientific observation and deduction for eighty years with childlike enthusiasm, and after asserting that for its lenses and scalpels there did not exist a single mystery, the nineteenth century at last seems to perceive that its efforts have been in vain, and its boast puerile. Man is still walking about in the midst of the same enigmas, in the same formidable unknown, which has become even more obscure and disconcerting since its habitual neglect. A great many scientists and scholars today have come to a halt discouraged. They realize that this experimental science, of which they were so proud, is a thousand times less certain than the most bizarre theogony, the maddest metaphysical reverie, the least acceptable poet's dream, and they have a presentiment that this haughty science which they proudly used to call "positive" may perhaps be only a science of what is relative, of appearances, of "shadows" as Plato said, and that they themselves have nothing to put on old Olympus, from which they have removed the deities and unhinged the constellations.[5]

Aurier's indictment of positivism and science recalls words of Novalis, written in 1799:

> Physics has now reached its heights, and we can now more easily survey the scientific guild. In recent times the poverty of the external sciences has become more apparent the more we have known about them. Nature began to look more barren; and, accustomed to the splendor of our discoveries, we saw more clearly that it was only a borrowed light, and that with our known tools and methods we would not find or construct the essential, or that which we were looking for.[6]

In Aurier's view, science serves only animal needs, not the higher faculties of spirit. To remedy the problem, Aurier calls for mysticism:

> [I]t is mysticism we need today, and it is mysticism alone that can save our society from brutalization, sensualism, and utilitarianism. The most noble faculties of our soul are in the process of atrophying. In a hundred years we shall be brutes whose only ideal will be the easy appeasement of bodily functions; by means of positive science we shall have returned to animality, pure and simple. We must react. We must recultivate in ourselves the

superior qualities of the soul. We must become mystics again. We must relearn to love, the source of all understanding.[7]

French Symbolist art, then, shares the Romantic movement's spiritual concerns and objectives, but its means differ. To invigorate the spiritual faculties, and to represent the essential divinity of the phenomenal world, Romanticism developed the aesthetic of the sublime. To the same ends, French Symbolist art and much of the work of the Nabis, as exemplified by Paul Gauguin, Émile Bernard, Odilon Redon, Paul Sérusier, and Maurice Denis, among others, developed its own distinctive method, which is most concisely summarized as the intensification of color and the simplification of form.

In 1888, Émile Bernard, who worked closely with Gauguin at Pont-Aven in Brittany, advocated the simplification of colors and forms as the basis of his brand of Symbolism, or "Synthetism," also dubbed "Cloisonnism" by the critic Edouard Dujardin. Modelled after stained glass or cloisonné enamels, Bernard's Synthetist works are marked by areas of bright color enclosed by dark outlines, as exemplified in his *Breton Women in the Meadow* (1888). Bernard, always of a deeply spiritual bent, later claimed to have conceived of Synthetist art while pondering the mystical writings of Saint Denys the Areopagite. Soon after seeing Bernard's *Breton Women*, Gauguin painted his path breaking *Vision After the Sermon* (1888) which, with its intense colors, sharply delineated forms, and bold outlines, marked the crystallization of his mature style. Following Bernard, Gauguin believed that the simplification of colors and forms exemplified the most efficient artistic method of distilling the spiritual essences of things and revealing the Ideas.

Aurier, in his article "Symbolism in Painting: Paul Gauguin," in the *Mercure de France* of March 1891, celebrated Gauguin as the foremost innovator and exemplar of Symbolist art. Bernard, who considered himself to be the true father of the movement, was deeply offended, and the two artists forever parted ways. Bernard's work and ideas indeed had a profound effect on Gauguin, and Bernard was shortchanged by Aurier's article. Gauguin's Pont-Aven works of 1886 and his Martinique works of 1887 show a move toward brighter colors and more defined forms, but Gauguin's mature style emerged only after Bernard's *Breton Women*. Gauguin was so impressed by the work that he acquired it from Bernard and late in 1888 took it to Arles where he showed it to Van Gogh.

Regardless of who invented the method, however, Symbolist art's

characteristic intensification of color and simplification of form, which it applied largely to serve essentialist aims, initiated a process of abstraction that culminated by the early 1910s in Kandinsky's non-objective art and by the late 1910s in Piet Mondrian's abstract reductivism. Essentialism thus provided an important early impetus for the emergence of abstraction in 20th century Western art.

According to the Neoplatonic canon which, as in Aurier's analysis, underpins French Symbolist art, the revelation of essences requires a mystical turn inward. Symbolism requires the artist to be faithful principally to a subjective revelation. Symbolist art, in effect, requires the artist to follow Caspar David Friedrich's exhortation:

> A painter should not merely paint what he sees in front of him, he ought to paint what he sees within himself. If he sees nothing within, he should not paint what he sees before him, lest his paintings resemble those screens behind which we expect to find the sick or the dead. Mr. X [the average person] has seen only what all but the blind can see; one should expect artists to see more than that.[8]

The revelation of Ideas in Symbolist art requires the artist's absorption in the divine light of the *nous*. As Plotinus wrote, "He that has the strength, let him arise and withdraw into himself, foregoing all that is known by the eyes, turning away forever from the material beauty that once made his joy" (Enneads I,6,8), and "Only the mind's eye can contemplate this mighty beauty" (Enneads I,6,9). Symbolism must thus comply with Friedrich's further injunction: "Close your eye, so that your picture will first appear before your mind's eye. Then bring to the light of day what you first saw in the inner darkness, and let it be reflected back into the minds of others."[9] Gauguin represents this kind of mystical absorption in his figures with eyes closed, such as *Shell Idol* (1893), *Christ on Mount Olive* (1889), and *Self Portrait in Stoneware* (1889). Contemplative figures were also a favored subject of Odilon Redon, especially during the early 1890s.

Johann Wolfgang von Goethe, a leader of the *Sturm und Drang*, in a discussion of the creative process, also alludes to such a contemplative state:

> The higher the soul rises toward an awareness of the proportions which alone are beautiful and eternal, whose main accords can be demonstrated but whose secrets can only be felt and in which the God-like, vital genius bathes in blissful harmony, the more these beauties enter into the spirit and

seem to become one with it, so that it will not be satisfied by anything else nor create anything else, the more happy and magnificent is the artist, and the more deeply we bow before him, worshiping him as the anointed of God.[10]

Symbolist art, like Romantic art, however, seeks to represent not only a subjective revelation but also phenomenal things. Both Symbolist art and the sublime landscapes of Romantic art thus manifest a symbolic synthesis of the ideal and the phenomenal domains of life. In Symbolist art, the intensification of color and the simplification of form manifest a process of spiritual purification through which material nature is revealed in its essential forms. In Platonic terms, Symbolist painting is thus an expression of *epistēmē*, a revelation of the true essences of things. In the Symbolist view, Realism, Impressionism, and naturalism, because they concern only appearances, reflect only *doxa*, mundane empirical knowledge. These types of art, as Gauguin wrote, are "bound by the shackles of verisimilitude....They focused their efforts around the eye, not in the mysterious centers of thought..."[11] These types of art, Gauguin thought, represent only shadows and reveal nothing of divine essences. As Aurier wrote of realist artists, with Neoplatonic airs of *de haut en bas*,

They are the poor stupid prisoners of the allegorical cavern. Let us leave them to fool themselves in contemplating the shadows that they take for reality, and let us go back to those men who, their chains broken and far from the cruel native dungeon, ecstatically contemplate the radiant heaven of Ideas.[12]

The experience of beauty, according to Plotinus, leads to the purification of the soul in the contemplation of the Ideas. The experience of beauty provokes anamnesis, a reactivation of the soul's innate knowledge of the Ideas, knowledge which, according to Platonic thought, is likely to be forgotten after the soul's corporeal embodiment. In the experience of beauty, and in the experience of anamnesis that it provokes, therefore, the prisoner of Plato's cave is, at least for a moment, liberated. In anamnesis, as Aurier wrote, "We remember unconsciously the times when our souls relaxed in the marvelous garden of Eden of the pure Ideas."[13] In *The Marriage of Heaven and Hell*, Blake wrote:

If the doors of perception were cleansed everything would appear to Man as it is: infinite.

For Man has closed himself up, till he sees all things through narrow chinks
of his cavern.

In anamnesis, the "doors of perception" are cleared. The Symbolist artist,
to represent the Ideas, must work from an experience of anamnesis.
Symbolist art, then, seeks its inspiration from a state of profound spiritual
introspection.[14]

From the Symbolist standpoint, Neoplatonism comes to terms with
Plato's condemnation of art and poetry as twice removed from the Ideas,
as shadows of shadows. As Plato wrote,

> [T]hese poetical individuals, beginning with Homer, are only imitators; they
> copy images of virtue and the like, but the truth they never
> reach....[P]ainting and drawing, and imitation in general...are far removed
> from the truth, and the companions and friends and associates of a principal
> within us which is equally removed from reason, and...they have no true or
> healthy aim. (*Republic* X,603)

Plato therefore would banish artists from the ideal state. An artist or poet,
in Plato's view,

> being concerned with an inferior part of the soul,...we shall be right in
> refusing to admit him into a well-ordered State, because he awakens and
> nourishes and strengthens the feelings and impairs the reason....[I]n the soul
> of man,...the imitative poet implants an evil constitution, for he indulges the
> irrational nature....[H]e is a manufacturer of images and is very far from the
> truth. (*Republic* X,605)

In spite of this, Plato allowed that if an adequate defense were mounted
against his charges against art, he would permit artists into the ideal state:

> [L]et us assure our sweet friend and the sister arts of imitation that if she
> will only prove her title to exist in a well-ordered State we shall be
> delighted to receive her....Shall I propose, then, that she be allowed to return
> from exile, but upon this condition only—that she make a defense of herself
> in lyrical or some other metre?....And we may further grant to those of her
> defenders who are lovers of poetry and yet not poets to speak in prose on
> her behalf: let them show not only that she is pleasant but also useful to
> States and to human life, and we will listen in a kindly spirit; for if this can
> be proved we shall surely be the gainers—I mean, if there is a use in poetry
> as well as a delight. (*Republic* X,607)

Plato speculated about the possibility of an acceptable art, one based in essences rather than phenomenal images:

> Now do you suppose that if a person were able to make the original as well as the image, he would seriously devote himself to the image-making branch?...The real artist, who knew he was imitating would be interested in realities and not in imitations. (*Republic* X,599)

Symbolist art answers Plato's charges, and meets his conditions for a defense of art, for the simple reason that it represents not just phenomenal images, but the divine essences of things. In defense against Plato's charges, Symbolism finds an ally in Plotinus. Plato's dualism, his conception of spirit and matter as separate and opposed ontological domains, obviates the possibility of a material representation of the Ideas. Plato conceives of all material things as mere shadows or gross images of the Ideas. In Plotinus's ontological scheme, on the other hand, material nature is conceived as a necessary emanation or extension of the One; material things, while gross, are imbued with the divinity of their unitary source, and are conceived as existing "in" the One. Material things, then, in their essences, are divine representations of the One and the *nous*. The divine essences of things, according to Plotinus, shine forth in beauty. Consistent with Socrates' assertion that in the ideal world, colors appear "far brighter and purer" than those in the earthly domain (*Phaedo* 110C), the Symbolist artists found that the divine essences of material things, their "splendor" in Plotinus's terms, could be best distilled by the intensification of color and the simplification of form.

Clearly, Plotinus is more favorably disposed toward the arts than Plato. Plotinus asserts that art can express the artist's introspective experience of the harmony or "symmetry" of the ideal, or the "intelligible," domain. As examples:

> [I]f anyone despises the arts because they produce their works by imitating nature, we must tell him, first, that natural things are imitations too: and then he must know that the arts do not simply imitate what they see; They go back to the *logoi* from which nature derives; and also that they do a great deal by themselves: since they possess beauty they make up what is defective in things....
>
> It would be false to ascribe [the imitative arts] to the intelligible realm except in the sense that they are contained within the mind of man. On the other hand, to proceed from the observing of the symmetry of living things

to the symmetry of all life is to exercise a part of that faculty which, even here below, knows and contemplates the perfect symmetry of the intelligible realm. The same must be said for music; since its thought is on rhythm and harmony, it is not unlike heavenly harmony....

The arts which produce sense objects, such as architecture and carpentry, so far as they make use of symmetry, have their principles in the intelligible world and participate in its wisdom. (*Enneads* V,8,1; V,9,11)

By its revelation of things in their divine essences, Symbolist art has implications for the moral transformation of both the artist and the viewer of the work of art, or *Bildung* in German Romantic terms. Shown in their divine essences, things are sanctified. Our moral attitudes are effected in the perception of things as sacred. The Romantic critique of the disenchantment of modern life is largely a critique of objectifying attitudes, of "instrumental rationality" in Weber's terms. According to the prevalent rationality of the modern sciences, technologies, and industries, utility is the ultimate measure of value, and all things, people included, are subject to a cold calculation of utility. As Schiller wrote, "Utility is the great idol of the age." People thus can be exploited and nature plundered without moral compunction. This becomes possible in a world in which people are, as Novalis put it, "accustomed to despising everything great and miraculous and regard [all things] as the dead effect of natural laws."[15] On the other hand, in the perception of things as sacred, things are perceived as ends in themselves. In the theological terms of Martin Buber, people and things are thus recognized as "Thou" rather than "It." Symbolist art's transformation of moral attitudes in the perception of things in their divine essences thus fulfills Plato's demand that a defense of art "show not only that she is pleasant but also useful to States and to human life"(*Republic* X,607).

Symbolist art shares the Romantic longing to reconnect to nature. Its celebration of "pure" and "unspoiled" peoples, as shown in its many paintings of rural peoples and landscapes, is most pronounced in Gauguin, who sought a pastoral Arcadia in the native cultures of the Marquesas Islands and Tahiti, cultures nonetheless already tainted by French colonization. Idealizing primitive and "savage" peoples, Gauguin, in effect, challenged then prevailing British anthropological assumptions, such as those of Edward Tylor and Lewis Henry Morgan, which held that primitive cultures are inferior from an evolutionary standpoint, and modern Western cultures exemplify human progress. These kinds of assumptions, in tandem with the Hobbesian-type notion that "uncivilized" peoples are brutal and

need to be tamed by civilization, were part of the conventional wisdom of European colonizers, for whom the "white man's burden," as a matter of Christian compassion, was to civilize the world's primitive and non-Western peoples. Gauguin, who agitated against the colonial authorities for the rights of the Pacific island natives, took the opposite Rousseauian-type view that civilization corrupts the noble savage. To reverse the moral and spiritual degeneration of the modern world, in Gauguin's view, the primitive nature of "savage" peoples must be preserved and revitalized. The Pacific island cultures Gauguin visited, it should be noted, were relatively strife-free, and happened to be suited to a Rousseauian perspective. Many other pre-modern cultures do not fare so well and show the Hobbesian paradigm in a better light.[16]

The innovations of French Symbolist art had an profound and enduring impact on the course of 20th century art. Its distinctive method—the intensification of color and the simplification of form—is a hallmark of much of early 20th century modernist art, in the works of artists as diverse as Munch, Mondrian, Kandinsky, Cézanne, Matisse, and Picasso.[17] Cézanne, Matisse, and Picasso, however, who had little or no interests in philosophical or spiritual missions for art, put these characteristics to the service of different purposes.

The Symbolist moorings of Edvard Munch, on the other hand, are unambiguous. Munch grew up in the provincial bourgeois atmosphere of late 19th century Kristiania (renamed Oslo in 1925), in a repressed puritanical family, and while still a child, lost his mother and sister to tuberculosis. Early on, Munch viewed art as a form of emotional catharsis and an expression of psychic pain. At the age of 21 he took up with the radical Kristiania bohemians led by the anarchist Hans Jaeger, who had contempt for the existing institutions of church, state, and marriage. Jaeger, who was twice imprisoned for publishing his iconoclastic novel *Fra Kristiania-Bohemen* in 1885, which laid out a utopian vision of communal living and free love, demanded absolute freedom of emotional self-expression. The Kristiania bohemians believed that art should be didactic and help raise the consciousness of the working classes. Munch therefore sought to avoid the intellectual obscurity that characterizes much high art. From 1889 Munch spent various periods in France and there became familiar with the Symbolist *Mercure de France* circle, befriending Stéphane Mallarmé and the Dutch Symbolist poet Emanuel Goldstein. While in France Munch witnessed the expressive power of intensified color and simplified form in Symbolist art.

Munch is generally categorized as an expressionist and, in keeping with the genre, his art expresses personal emotions. The emotions he expresses, however, have extra-personal significance. Like the Romantics and the Symbolists, Munch's art expresses a yearning to overcome the spiritual lacunae of modern life. Munch differs crucially from the Romantics and the Symbolists by his pessimism. Munch's pessimism, like Edward Hopper's later, thus placed him at a crossroad where modernism begins to verge toward postmodernism. Munch's art expresses social estrangement, hopelessness, and existential meaninglessness, and shows no hint of either imminent or eventual salvation. Although Munch ostensibly believed that socialist ideals would eventually triumph, there are no signs of such hope in his art. In his urban scenes, faceless and bewildered crowds march mechanically down the streets, as in *Evening on Karl Johansgate* (1892) and *Anxiety* (1894). In Munch's figures before windows, in contrast to the German *Fensterbild* works, which typically intimate hope, lone figures stare out into emptiness and darkness or toward a phantom window outside the picture space, as in *Night in Saint-Cloud* (1890) and *Morning* (1884). For Munch the object of sentimental longing is not God or nature, but love itself. He yearns for the human love that would be manifest in an authentic social world, but feels condemned to perpetual frustration.

## Piet Mondrian

Piet Mondrian's relationship to the Symbolist movement is complex. For him, consistent with both Romanticism and Symbolism, art is a means to communicate ultimate spiritual realities. Trained as an academic realist, in 1903 he became interested in Theosophy, a religious philosophy devoted to the direct mystical experience of divinity, and at around this time also developed an interest in Symbolist art. His pallette became much brighter as he went through a Symbolist period from about 1905-1911. He joined the Theosophical Society in 1909. As a dedicated Theosophist, Mondrian became familiar with Neoplatonic thought, which undergirds the Theosophical writings of Helena Blavatsky, Annie Besant, Rudolf Steiner, and Matthieu Schoenmaekers. He must also have known of Besant and C.W. Leadbeater's 1901 *Thought Forms*, which details the spiritual and emotional significance of many various colors and forms.[18] In 1911 he went to Paris and became fascinated with Cubism and its resolution of objects into geometric forms. From this time, he begins to develop his "pure plastic art," or completely abstract art. By 1915 he developed his mature art

symbolism, consisting almost exclusively of horizontal and vertical black lines and rectangular planes of primary colors and white, taking the Symbolist method of simplifying color and form to an extreme.

Inspired also by Hegelian philosophy, which was in currency among European idealist intellectuals at the time, Mondrian developed a dialectical theory of art history. His theory identifies "individualism" as the root of all evil in human society and "universalism" as the good which humanity is destined to realize. Consistent with his objection to individualism, Mondrian rejected the Romantic and the expressionist notions that art should express personal feelings. He sought to overcome self-expression in a simple universal language of symbols, represented by horizontals, verticals, and primary colors.

According to Mondrian's dialectical theory of the evolution of society and art, much of which is expressed in his essays "Neo-Plasticism: The General Principle of Plastic Equivalence" and "Plastic Art and Pure Plastic Art," the earliest stages of human society manifested a primitive form of universalism, and art during these stages was generally non-figurative.[19] As social relations became more complex, individualistic stages followed, accompanied by figurative art. Mondrian thought that the individualistic stages were nearing an end. In his view, contemporary life was beginning to reach a higher universalistic stage, accompanied by the return of a more evolved non-figurative or abstract art. Consistent with both Neoplatonic and Hegelian thought, he believed that the human spirit is compelled toward its self-realization in universal truth. Material nature, however, in his view, embodies only relative truth. Figurative art, then, can only represent relative truth. The most evolved art, therefore, must be abstract. For this reason he criticized Cubism as retrograde for remaining based in figuration. According to his reasoning, as the human spirit progressively overcomes nature and relative truth, it will realize the universal consciousness. Art will at the same time become more abstract as it represents the collective consciousness of universal truth. Abstract art thus signals the arrival of the universalistic stage of human history.

Mondrian did not share the Romantic and Symbolist wariness toward modern scientific and technological progress. In his view, the universalistic consciousness emerges concurrently with the growth of industry and the emergence of the modern metropolis. For Mondrian, rural life manifests individualism, and the collective life of the modern city exemplifies the universal consciousness. In his view, the growth of science and industry, because it enables people to overcome the constraints of material nature,

freeing them to contemplate spiritual things, signifies the human spirit's progress toward universal truth.[20]

The progress of the human spirit toward the universal consciousness, according to Mondrian, is realized through a progressive resolution of the imbalance and tension between material nature and the human spirit. He calls this imbalance "tragedy."[21] In the individualistic stages of history, in his view, these oppositions are in mutual tension and imbalance. In the impending universalistic stage, these oppositions will be resolved and harmony will be restored.

In Mondrian's art, the "balanced relations" of formal elements, as in his balance of colors and forms, represents the restoration of the "dynamic equilibrium" of the opposed domains of spirit and nature. Mondrian's art thus symbolically resolves "tragedy." He regards spirit as "dynamic" and material nature as "static"; nature requires spirit to be animated. He identifies spirituality with inwardness, contemplation, activity, universality, absolute truth, and the masculine, and material nature with outwardness, emotionality, passivity, individuality, relative truth, and the feminine.[22]

Mondrian's identification of the feminine with nature, individuality, and relative truth reflects his explicit misogyny. As he wrote in 1920, "The feminine and the material life rule society and shackle spiritual expression as a function of the masculine. A futurist manifesto proclaiming hatred of woman (the feminine) is entirely justified. The woman in man is the direct cause of the domination of the tragic in art."[23] By 1917, consistent with his loathing of nature, Mondrian was absolutely opposed to the use of curved lines in art, because they are suggestive of natural form. To symbolically overcome the static and relative sphere of material nature which, for Mondrian, is a dark veil over spirit and truth, imperfections such as curved lines must be straightened out. He believed that his straight lines and right angles "purify" biomorphic form.[24]

Straight lines and right angles in fact rarely if ever occur in nature, but are typical characteristics of the products of human industry. Straight lines and right angles are essential forms not of nature but of human technology and the technological landscape of the modern metropolis. Mondrian's works do not symbolically purify nature, but annihilate nature. His attempt to purify nature through straight lines and right angles represents his wish to transmute nature into a man-made artifice. His efforts to annihilate natural form thus reflect the objectifying attitude of instrumental rationality and its efforts to subjugate nature to human will. From a psychological standpoint, it appears not unlikely that Mondrian's efforts to repress

nature, along with his identification of nature with the feminine, bear some relation to his repressive orthodox Calvinist upbringing and his apparent lifelong avoidance of sexual intimacies.

Mondrian was equally inspired by the Symbolists, who viewed art as a means toward spiritual realization, and by the Cubists, who had no ostensible spiritual or philosophical aspirations. His work, however, manifests a unique synthesis which is incompatible with both Symbolism and Cubism. Consistent with both Romanticism and Symbolism, he views art as a means of harmonizing oppositions and of representing an essential spiritual reality. For Mondrian, Cubism's analytical reduction of objective forms into geometric planes, which is derived ultimately from Cézanne, is put to the service of an essentialist agenda. Mondrian sought to reveal universal truth by means of the balanced relations of his abstract forms. In Cubism he found a method of simplification by which spiritual essences could be distilled. His spiritual and philosophical aims, however, are out of sync with the formal and aesthetic priorities of the Cubist movement. One the other hand, his hostility toward nature and his idealization of science and industry are anathema to Symbolism's idealization of nature and wariness toward scientific and industrial progress. For Mondrian, unlike the Symbolists, nature is not a representation of divinity, but is an impure thing, a kind of "coat of dirt" over spirit which must be cleansed away in the process of the artist's alchemical distillation of universal truth. Mondrian's loathing of nature contradicts Plotinus's assertion that material nature is imbued with the divinity of its unitary source, although it appears to correspond in spirit to certain passages in which Plotinus refers to nature as "dark with evil" and "a filthy thing"(Enneads I,6,5), passages which dramatize Plotinus's assertion that despite its essential divinity, material nature is the basest and grossest emanation of the One. For Mondrian, in contrast, material nature is not in the least bit divine. Mondrian's disposition toward material nature, therefore, more closely resembles the dualism of Plato than the relative monism of Plotinus. For Mondrian, like Plato, the ideal and the material aspects of being constitute separate and opposed ontological domains.

## Wassily Kandinsky

Wassily Kandinsky was inspired early on by various forms of Post-Impressionism, as shown in his radiantly colored figurative works of the first decade of the 20th century. He was especially inspired by Symbolist

art.[25] By the early 1910s, he began painting non-figurative compositions and elaborated a theory of the spiritual significance of abstract art. Kandinsky's thought evinces some fundamental Romantic attitudes. A Russian who spent much of his career in Germany, Kandinsky saw art as a means of opposing materialism and utilitarianism, and of reinvigorating spiritual awareness in the modern world. Many of his basic ideas are expressed in his 1912 treatise *Concerning the Spiritual in Art*.

For Kandinsky, materialism is the foremost obstacle to spiritual self-realization. He believed that human consciousness evolves through a progressive transcendence of restrictive materialistic beliefs. In his view, authentic art expresses an artist's intrinsic spiritual "internal necessity" to overcome all material barriers to complete self-expression and spiritual self-realization. Like Mondrian, Kandinsky believed that art history reflects a general process of human spiritual evolution, and that abstract art, because it transcends the sphere of material nature, signifies the advent of an advanced stage of human spiritual development. In Kandinsky's view, figurative or "objective" art affirms materialism and thus retards the evolutionary progress of the human spirit. Figuration, in his view, also obstructs the spiritual "inner resonance" of colors and forms. Thus Kandinsky, like Mondrian, criticized Cubism for remaining based in figuration, while also recognizing Cubism's essential role in art's inexorable movement toward abstraction. Kandinsky, then, like Mondrian, believed that figurative images obfuscate spiritual truth and that spiritual realities are best represented by abstract art.

In the early years of the Russian Revolution, Kandinsky hoped that the Revolution would usher in a new age of spiritual enlightenment. He had an apocalyptic vision of history, seeing cataclysmic periods of rapid change as especially ripe for a "spiritual revolution." Artists, in his view, experience these periods as especially invigorated by internal necessity. Periods of strife, in his view, stimulate the human spirit to seek unrestricted freedom.[26] In the modern world, according to Kandinsky, inner necessity is activated by the "nightmare of materialism," causing artists to

> turn away from the soulless life of the present toward those substances and ideas that give free scope to the non-material strivings of the soul....When religion, science, and morality are shaken...and when outer supports threaten to fall, man withdraws his gaze from externals and turns it inwards. Literature, music, and art are the most sensitive spheres in which this spiritual revolution makes itself felt.[27]

Consistent with the Romantic concept of the artist as genius, Kandinsky saw the artist as, like the shaman of pre-modern societies, gifted with extraordinary spiritual vision, and charged to communicate this vision to others. As he wrote, with essentialist overtones, "This eye penetrates the hard shell, the external 'form', goes deep into the object and lets us feel with all our senses its internal 'pulse'."[28] Kandinsky regarded artists as spiritual redeemers of society who are at the apex of a social triangle. His concept of the social triangle is represented by the frequent appearance of triangles in both his semi-abstract transitional works of the early 1910s and his mature abstract works. In Kandinsky's symbolism, triangles signify a general process of human spiritual evolution. At the bottom of the social triangle, in his view, is the mass of unenlightened humanity. The artist redeemers, at the top, must "drag the heavy weight of resisting humanity forward and upward."[29]

Consistent with Hegel's philosophy of history as well as with similar Theosophical ideas with which he was familiar, Kandinsky believed in the existence of an inexorable historical process through which spiritual truth is progressively unveiled to human consciousness. He saw artists as principal custodians of the redeeming consciousness by which humanity will be spiritually transformed. By virtue of the artist's transformative vision, in his view, more and more people will eventually reach the apex of the social triangle. He sees this as an ongoing process:

This victory proceeds slowly. The new value conquers the people quite gradually. And when it becomes undoubtable in many eyes, this value...will be turned into a wall—a wall which is erected against tomorrow....The barriers are constantly created from new values which have overthrown the old barriers....In like fashion our epoch, esteeming itself to be completely free, will encounter certain limits: these limits, however, will be shifted "tomorrow."[30]

Kandinsky's insistence on the social importance of a spiritual revolution corresponds to the German Romantic concept of *Bildung*. For Kandinsky, social evolution is dependent upon a collective transformation of spirit. He believed that art plays an essential role in facilitating the requisite spiritual condition of a better social world.

From about 1910 on, Kandinsky sought through his art to represent his vision of the human spirit's perpetual struggle against the material resistance of nature. The works of the 1910s especially, prior to his transition during the early 1920s toward more static geometric

compositions, signify the dynamic tension between warring oppositions and the impending triumph of spirituality over materialism.[31] In many of the semi-abstract transitional works of the early 1910s, for example, he presents images of storms, battles, angels with trumpets, and tumbling city towers, to represent the ongoing struggle between good and evil.[32] These oppositions are represented by his language of abstract forms and colors in his later non-objective works, as explained in *Concerning the Spiritual in Art*. As in his semi-abstract transitional works, the abstract works juxtapose symbolic oppositions. According to his analysis of the symbolism of color, for example, the red end of the spectrum represents the more intense emotional and spiritual states, while the blue end signifies stillness, inwardness, coolness, and more sublimated states.

In *Concerning the Spiritual in Art*, Kandinsky presents his theory of synesthesia, an elaboration of the correspondences between colors, forms, physical sensations, emotions, and spiritual states. The concept of synesthesia can be traced to Baudelaire's poem "Correspondences," and in turn to Swedenborg's concept of correspondences. From an essentialist standpoint, synesthesia, because it reveals the correspondences between phenomenal things and mental or spiritual states, is a method by which to reveal ideational essences in perceptible forms. Kandinsky eventually extended his theory of synesthesia to an analysis of music, identifying the parity between colors and the sounds of various musical instruments.[33]

Consistent with his belief that the human spiritual struggle continues indefinitely, Kandinsky's compositions resist a sense of closure. Especially before he joined the Bauhaus in 1922, where he was influenced by Walter Gropius's advocacy of simplicity and economy of form, his compositions are frequently mired in complications. The chaos of the earlier works signifies the urgent problem of the lost spiritual life and represents an internal confrontation with the problem of lost meaning. For Kandinsky, spiritual coherence lies implicit within the disorder. He believed, however, that this coherence must become manifest to human consciousness only gradually through a laborious process of spiritual struggle. The sense of irresolution remains in his works until the end, but is especially marked in the earlier works.

While Kandinsky's ideas evince Romantic attitudes in some clear respects, they also run counter to ideal typical Romanticism in a basic way. His difference from the Romantic attitude is implicit in his rationale for abstract art. For Kandinsky, like Mondrian, figurative art affirms materialism, and the process of spiritual growth requires art to transcend

figuration. For both artists, abstract art signifies not just a repudiation of materialism, but a repudiation and negation of material nature itself. Although Kandinsky, who never abandoned biomorphic form, did not have as virulent an aversion to nature as Mondrian, both artists see material nature as an evil which must be overcome.

Kandinsky and Mondrian's aversions to material nature are anathema to the spirit of Romanticism, which opposes the alienation of nature and seeks to reveal the immanence of divinity in nature. Symbolism, by its essentialist demand that art principally represent not material nature but the non-material essences of nature, mandated a move toward abstraction. But its intensified and simplified colors and forms, as in the Romantic aesthetic of the sublime, seek not to negate material nature but to celebrate nature's essential divinity.

Both Romantic and Symbolist art seek to synthesize and harmonize spiritual and material oppositions. Kandinsky and Mondrian, to the contrary, in their quests for spiritual purity, seek as far as possible to abstract spiritual form from material nature. Both artists symbolically negate nature in the process. In their views, material nature defiles spiritual form. Kandinsky, like Mondrian, therefore, falls more in line with the dualism of Plato than the monism of Plotinus. For both Kandinsky and Mondrian, the spiritual and material domains of being are ineluctably opposed. Nevertheless, Kandinsky and Mondrian's dualism, unlike Plato's, is not so extreme that it obviates the possibility of spiritual representations in material objects of art. Both artists take the Neoplatonic view that art can express spiritual truth. Their dualism is thus more moderate and compromising than that of Plato. It does not require them to reject art entirely, but only to reject the figurative representation of material objects.

Franz Marc, who with Kandinsky founded the *Blaue Reiter* group in 1911, also based his gradual move toward abstraction on a rejection of material nature. His well-known animal paintings, which express a Romantic idealization of material nature, were based on the notion that animals embody the spiritual purity and innocence of unspoiled nature, in contrast to "ugly" and "profane" human beings.[34] As he wrote, "I am trying to heighten my sensitivity to the organic rhythm of all things and trying to empathize pantheistically with the tremulous coursing of the blood in nature, the trees, the animals and the air...."[35]

From 1912 on, however, as his paintings became more abstract, Marc sought to purge his work of figurative images. His move toward abstraction was concurrent with his increasing aversion toward material

nature. In a letter to his wife in 1915, he wrote that even in animals, he saw "so much that was repugnant to my feelings, so much that was ugly, that my images instinctively...became more and more schematic, more abstract....[T]rees, flowers, earth, everything showed me more and more ugly, repugnant aspects—until at last the ugliness and impurity of Nature suddenly became clear to me."[36] By 1914, two years before his death during military service, in his efforts to represent a pure spiritual reality by means of intensely colored crystalline forms, Marc began to produce completely abstract works such as *Playing Forms* and *Fighting Forms*. Like Mondrian and Kandinsky, Marc's move toward abstraction was motivated by a philosophical dualism which necessitated a rejection of material nature.

# Chapter 3
## Surrealism and Abstract Expressionism

Resisting the disenchantment and the rationalization of modern life, Romantic art seeks, by means of the aesthetic of the sublime, to revitalize the spiritual life in extraordinary feeling-states of wonder, astonishment, terror, and awe. According to Burke, these feelings are aroused by the excitement of the basic human instincts for self-preservation. The aesthetic of the sublime thus appeals to unconscious activities of the mind. In this respect Romantic art prefigures Surrealism and Abstract Expressionism which, according to the theories these movements embraced, also achieve their emotional effects by the excitement of unconscious processes.

André Breton, the foremost Surrealist leader and spokesman, was inspired by Sigmund Freud's theories of the unconscious mind, dream symbolism and interpretation, and free association. For the Surrealists, Freud elucidated the creative potential of the primal depths of the mind, a potential which, the Surrealists thought, modern life represses and stultifies. For them, Freud particularly demonstrated the creative potential of dreams. Freud believed that dreams express unconscious emotions and feelings which ordinarily remain repressed in everyday life. The Surrealists thus found in dream imagery a means of dredging the creative potential of the unconscious mind and expressing the emotional intensity of unconscious life. For the Abstract Expressionists later, Carl Jung shed further light on the creative fecundity of the unconscious mind principally through his concepts of the archetype and the collective unconscious.

The Surrealists' belief in dreams as a source of artistic and spiritual inspiration has solid foundations in Romanticism. In Novalis's *Heinrich von Ofterdingen*, for example, a dream of an ideal "blue flower" is the catalyst of the protagonist's spiritual odyssey. As Heinrich extols the spiritual and creative fecundity of dream life:

Dreams seem to me to be a defense against the regularity and routine of life, a playground where the hobbled imagination is freed and revived and where it jumbles together all the pictures of life and interrupts the constant soberness of grown-ups by means of merry child's play. Without dreams we should certainly grow old sooner; and so we can regard dreams, if not as directly sent from heaven above, at least as divine gifts, as friendly companions on our pilgrimage to the holy sepulcher. Certainly the dream I dreamed last night will not have been an ineffectual accident in my life, for I feel that it reaches into my soul as a giant wheel, impelling it onward with a mighty swing.[1]

The anthropology of primitive and ancient cultures also influenced both Surrealist and Abstract Expressionist thought. Especially important was Sir James Frazer's massive *The Golden Bough*, originally published in 1890, which influenced the ideas of both Freud and Jung and remained influential upon anthropological thought for several decades.[2] The book details the religious beliefs and ritual practices of many diverse cultures and postulates common themes in the myths and legends of ancient and tribal cultures. Frazer demonstrates that religion and myth function in these cultures to salve fear and uncertainty and to confer meaning on life. He also illustrates the importance of dreams and dreaming in primitive religious thought, and shows that many tribal people believe that dreams convey messages from spirits and gods. He further shows that primitive people typically view nature as permeated by spiritual power.

Also influential were Lucien Levy-Bruhl's *How Natives Think* and *Primitive Mentality*, which postulate basic differences between the mentalities of primitive and modern people.[3] In Levy-Bruhl's view, the thought patterns of primitive people, unlike those of modern people, are based on a principle of "mystical participation." Primitive people see human life, the collective tribal life, and all objects and events as inextricably bound up with supernatural forces. Modern thought, in contrast, as Levy-Bruhl points out, due to its rationalistic tendencies to divide, separate, and classify things, can hardly conceive of the mystical connectedness of things that primitive people take for granted. Levy-Bruhl's studies corroborate Frazer's observation that primitive people see dreams as messages from the spirit world and gods. Levy-Bruhl's studies also demonstrate the significance of totems as guardian spirits in tribal religious thought.

For both the Surrealists and the Abstract Expressionists, Frazer and Levy-Bruhl's ideas brought in sharp relief the relative spiritual impoverishment of modern life and demonstrated the fundamental

importance of dream imagery and myth for the creative process and for the vitality of psychological life. Implicit in much of Surrealist and Abstract Expressionist art is a Rousseauian-type idealization of the life of pre-modern people. Both movements express a basic assumption that modern civilization tends to stifle human capacities for psychological profundity and that a regeneration of life will require a reactivation of primal dimensions of consciousness.

As the immediate progenitor of Surrealism, the Dadaist movement grew out of disgust with the horrors of World War I. In the view of the Dadaists, the "age of reason" led the Western world to self-annihilation in a mass slaughter. Continual advances in science and technology also resulted in no diminution of warfare and strife. In an assault on reason, the Dadaists experimented with automatist or chance methods of artistic execution which would mitigate the role of rationality in the creative process and allow for the expression of elemental feeling-states. Zurich Dadaism is especially significant in this regard. Although within earshot of much of the bombing, Zurich provided a haven for many artists seeking refuge from the war. The Dada performances at the Cabaret Voltaire in Zurich were based on a calculated irrationality. Their improvisational jazz and African drum jam sessions, nonsense poems, simultaneous readings, and wanton screaming sessions, leaving much to chance, in which performers sometimes wore masks based on African tribal designs, sought to express and evoke a pre-rational mentality. The Zurich Dadaist Jean Arp was a pioneer of the technique of automatism, making compositions by dropping scraps of paper randomly onto a surface.

"Pure psychic automatism," as it was named by Breton, became the basis of the Surrealist method. To give free reign to unconscious associations and images, and thus to the emotional intensity of unconscious mental life, automatism requires the artist to relinquish rational control over the creative process and submit to a passive, receptive state analogous to that of a trance medium. Automatism is exemplified in the Surrealists' figurative and non-figurative "inscapes" of unconscious imagery, the figurative works emulating the anti-logic of dream imagery. Surrealist art seeks to activate unconscious mental processes and provoke non-rational modes of perception by its disruptions of logic. The Surrealists were inspired by the poetry of Lautréamont, especially the 1837 prose poem *Les Chants de Maldoror*, which by its pervasive non-rationality exemplifies the Surrealist ideal. They were also influenced by the Zurich Dadaists' photomontages, which mirror the craziness of the actual social world by

their incongruous juxtapositions of photographic images, and provoke the spectator's critical confrontation with the problem of lost meaning.

Despite Surrealism's ideal of "pure" automatism, Surrealist art-making often entails a final stage of rational mediation in which forms and images are finished according to the artist's conscious and deliberate intentions. A complete suspension of rational control is often implicated only in the initial stage in which the basic subject and design are established. The basic design is then molded in accord with the artist's wishes. Andre Masson, for example, would often begin a work by randomly scribbling an inchoate web of lines. In this web he would find a vague matrix of images which he would then deliberately shape into more coherent forms. This technique, although not conceived as "automatism" at the time, was pioneered by the 18th century English artist Alexander Cozens, who found that random blots made on drawing paper could provide the basis for a figurative composition. Cozens in turn attributed the idea of the technique to Leonardo da Vinci, who observed that pondering recognizable shapes in wall stains can help activate the creative imagination.

Like German Romanticism, both Surrealism and Abstract Expressionism reacted against the disenchantment of modern life. Caught in a then-current wave of enthusiasm for socialist movements, many Surrealists laid much of the blame on bourgeois and capitalist culture for the oppression of the emotional life. Bourgeois and capitalist culture, in their view, by its insatiable drives for wealth and industrial expansion, its corresponding devaluation of more profound emotional and spiritual needs, and its subordination of masses of workers to its imperatives, stultifies the creative imagination. Conceiving of art as a form of revolutionary action or praxis, the Surrealists sought to supplant bourgeois rationality with the Surrealist imagination. Thus like the Romantics, the Surrealists believed that social reform must be founded on psychic reform, on changing predominant modes of feeling and thought. Surrealism sought to provoke these changes through marvelous and fantastic images. As Breton wrote in 1934,

> Under color of civilization, under the pretext of progress, all that rightly or wrongly may be regarded as fantasy and superstition has been banished from the mind, all uncustomary searching after truth has been proscribed....The imagination is perhaps on the point of reclaiming its rights....
>
> I am resolved to render powerless that hatred of the marvelous which is so rampant among certain people, ridicule to which they are so eager to

expose it. Briefly: The marvelous is always beautiful, anything that is marvelous is beautiful; indeed, nothing but the marvelous is beautiful.[4]

Surrealism was a principal inspiration for the artists who were to form the New York School of Abstract Expressionism. During World War II, many European Surrealists, including Breton, emigrated to the United States and settled in the New York City area. The prospective artists of the New York School generally shared the Surrealists' psychological and anthropological interests, but not their politics. Already by the late 1930s in America, the politics of the far left was widely associated, in intellectual circles, not with freedom but with Soviet tyranny.

Like the French Revolution for the Romantics, for the Abstract Expressionists, the horrific events of World War II highlighted the priority of inner psychic transformation over political action. The movement manifested a turn inward, away from the objective world of political intrigue and toward deeper immersion in the subjective world of the mind. The Abstract Expressionists found inspiration in the theories of Carl Jung, who recognized the transformative power of archaic forms. Among the New York School's many intellectual influences, the most important was that of Jung, whose concepts of the archetype, the collective unconscious, synchronicity, and psychic integration had a profound impact. The Abstract Expressionists did not have an intellectual spokesman of the caliber of an Aurier or Breton. Writings were produced by Barnett Newman, Mark Rothko, Adolph Gottlieb, and John Graham. Graham produced the lengthiest single work in *Systems and Dialectics in Art*,[5] but the book, written during the movement's nascent stage, is sketchy and lacks elaboration. Graham was largely responsible for the early dissemination of Jungian ideas to the prospective artists of the New York School.

The Abstract Expressionists generally were not comfortable with Surrealism's idealization of irrationality. The political climate of the time led them to associate irrationality with the mass insanity of Nazism. The Abstract Expressionists sought to implicate more conscious and rational activity in the art-making process while at the same time preserving automatism and the primal forms of unconscious expression that it enables. The Nazi's rabid nationalism and racism also highlighted the need for a universal art that would transcend ethnic and cultural differences. Abstract Expressionism found an intellectual rationale for a synthetic and universal form of art in Jungian psychology, which seeks an integration of conscious and unconscious processes. Jung's concepts of the archetype and the

collective unconscious provided the Abstract Expressionists with a conceptual basis for a language of universal symbols.[6] Although most of the Abstract Expressionists were familiar with Jung's concepts, there is little evidence that any of the artists studied Jung in great detail. Nevertheless, Abstract Expressionism's symbolism and methods turned out to be consistent with Jung's concepts of the archetype, the collective unconscious, psychic integration, and synchronicity.

Jung conceives of archetypes in psychological terms as basic structures of the human psyche which constitute the collective unconscious of humanity as a species. For Jung, as opposed to Freud, the unconscious is not in the mind but the mind is in the unconscious. The collective unconscious is a transpersonal dimension of the psyche in which all people participate. Freud recognized only the personal unconscious, conceived as the mind's repository of repressed personal experiences. Jung found that images often spontaneously arise in dreams and fantasies which are fundamental to the myths, histories, literature, and art of diverse cultures. These recurrent motifs, as archetypes, are symbolic patterns which are common to people of all cultures, ancient and modern. Archetypes encompass the concepts and life situations which are fundamental to cultures everywhere, such as God, Goddess, nature, birth, rebirth, death, wise man, hero, demon, and many others. Particular cultural manifestations of archetypes, however, such as the heroes of the Bible, are not archetypes in themselves, which are numinous in essence, but are images or representations of archetypes. Each culture establishes its own conceptions of God, nature, birth, rebirth, death, hero, and so on, developing variable archetypal representations in accord with its own unique traditions.

A principal goal of the Jungian therapeutic process is "psychic integration," in which conscious and unconscious psychic oppositions are brought into balance. Jungian psychoanalysis seeks a conscious assimilation of the archetypal contents of the unconscious mind; the unconscious must become conscious. This requires the analysand to complete a mythic "hero's journey" to the depths of the psyche. Jung likens psychic integration to an alchemical process. A higher self emerges through the dynamic conjunction of conscious and unconscious oppositions. In Jung's view, modern Western people, due to their excessive rationality and their tendencies to deny and repress the vital unconscious life, were especially in need of this integrative process. Jung recognized art as a means to facilitate the process. As part of his self-analysis, Jung himself painted many mandalas, which he construed as archetypal representations of

psychic integration.

Abstract Expressionism's non-figurative representations of archetypes are consistent with Jungian psychology. Jung permits a more abstract conceptualization of archetypes than is allowed by Platonism or Neoplatonism. For both Plato and Plotinus, archetypes are ideal models after which all things are created. Plotinus conceives of phenomenal things as emanations of the One, the unitary source of all things, and the *nous*, the reservoir of archetypes, and preserves Plato's belief that phenomenal things are created in the image of their archetypal sources. For both Plato and Plotinus, phenomenal things have a relationship of resemblance, or a mimetic relation, to the archetypes to which they correspond. An archetypal horse, therefore, if it is conceptualized visually, must look like a horse. An archetypal horse is the eternal and universal form of a horse abstracted from the particular qualities of temporal and corporeal horses. A visual representation of the archetypal horse, then, must seek to capture the horse in its universal and ideal rather than its particular and phenomenal form. Archetypes as conceived by Plato and Plotinus, according to the mimetic relation that exists between archetypes and phenomenal things, possess, in ideal form, the essential qualities of phenomenal things, such as their basic shape, features, and character. These ideal qualities determine the corporeal qualities of phenomenal things.

The simplified forms and colors of Symbolist art, then, are in accord with the Platonic assumption that ideal essences and phenomenal appearances have a relation of resemblance. In French Symbolist art, archetypal representations necessarily preserve a basic resemblance to corporeal objects. Symbolist art sought to distill the essence of phenomenal things by exaggerating their basic forms and eliminating superfluous detail. At the same time, the Symbolist tendency to intensify colors is suggestive of the divine light with which phenomenal emanations of the One are thought to be deeply imbued. While the archetypal representations of Symbolist art are abstracted significantly from phenomenal detail, they nevertheless preserve a significant resemblance to their corporeal subjects.

Jungian archetypes, as constituents of the collective unconscious, are conceived differently. Jung asserts that the content of an archetype is determined *a posteriori*. In Jung's scheme, archetypes exist *a priori* only as empty forms. According to Jung, archetypes are basic patterns of thought and action, of myths and of typical situations in life. They are abstract principles which assume content only through life experience. The specific content of archetypes as they are represented in human cultures is

determined by us. For Jung the archetype is "empty and purely formal," "determined as to its content only when it has become conscious and is therefore filled out with the material of conscious experience." As Jung writes, "There are as many archetypes as there are typical situations in life. Endless repetition has engraved these experiences into our psychic constitution, not in the form of images filled with content, but at first only as *forms without content*, representing merely the possibility of a certain type of perception and action."[7]

The content of archetypal representations, then, according to Jung, varies between cultures, according to the specific life experiences of cultures. From a Jungian standpoint, archetypes may be represented figuratively, but not by necessity. A Jungian archetypal representation may be either abstract or figurative according to an artist's discretion. Figurative Jungian archetypal representations, however, are based on specific cultural content which has been established, *a posteriori*, through life experience. Abstract Jungian archetypal representations, on the other hand, are best interpreted as efforts to apprehend the archetype in its *a priori* "empty" universal form, abstracted as far as possible from temporal content.

The titles of many Abstract Expressionist works suggest natural subjects. But in Jackson Pollock's *Autumn Rhythm* (1950), William Baziotes' *Summer Landscape* (1947), and Richard Pousette-Dart's *White Garden, Sky* (1951), as examples, mimetic relations are radically abstracted from phenomenal nature. These works in effect represent nature in its archetypal "empty form," abstracted from temporal content. They do so through biomorphism, the most simple and essential formal characteristic of phenomenal nature. They thus preserve only a minimal mimetic relation to nature in its temporal form.

By its use of abstract biomorphic imagery, which is also typical of much Surrealist art, gestural Abstract Expressionism represents a symbolic integration of natural and psychic processes. Abstract Expressionism, following Surrealism, conceives of the psyche as not separate from nature but as integral to nature's mutable organic processes. The biomorphic imagery of both Surrealism and Abstract Expressionism presents an illusion of dynamic motion signifying eternal and inexorable processes of natural and psychic flux. For both movements, therefore, non-figuration does not signify an idealistic aversion to material nature such as that of Mondrian and Kandinsky. They rather present psychic and spiritual processes as intrinsic to nature's organic processes. Emulating the pantheistic animism

of primitive and tribal people, the biomorphic images of Surrealism and Abstract Expressionism reflect a belief in the immanence of spirit in nature. A "sentimental" longing for the harmonization of the spheres of spirit and nature is symbolically resolved in the Surrealist and Abstract Expressionists' visions of the integration of these spheres in biomorphic imagery. By representing psychic processes as natural processes, both movements symbolically overcome the estrangement of human life from nature and spirit.

Barnett Newman's name for an archetypal representation is "ideograph," which he describes as "a character, symbol, or figure which suggests the idea without expressing its name,...a symbol or character...representing ideas."[8] Inspired by the crafts of indigenous American cultures, Newman believed that modern abstract art could replicate the spiritual intensity of the non-objective patterns of Native American crafts. Observing the abstract patterns of the Northwest Coast Indians, Newman concluded that abstract art is a primal art form. For the Northwest Coast Indian, according to Newman, "a shape was a living thing, a vehicle for an abstract thought-complex, a carrier of the awesome feelings he felt before the terror of the unknowable."[9] Rejecting charges that abstract art is a form of intellectual obscurantism, Newman wrote, "There is an answer in these works to all those who assume that modern abstract art is the esoteric exercise of a snobbish elite, for among these simple peoples, abstract art was the normal, well-understood dominant tradition. Shall we say that modern man has lost the ability to think on so high a level?"[10] The non-objective primordial imagery of Abstract Expressionism seeks to recover a pre-rational order of spiritual intensity which is largely lost in the modern world. As Graham wrote, the purpose of art should be to "reestablish a lost contact with the unconscious...in order to bring to the conscious mind the throbbing events of the unconscious mind."[11]

Many of the Abstract Expressionists found representations of these "throbbing events" in the archetypal images of pre-modern cultures. The Abstract Expressionists' fascination with archaic forms seems to mirror Jung's belief that because rationality and individuality are undeveloped in ancient and primitive cultures, archaic religions, myths, and art are direct expressions of the collective unconscious. The Abstract Expressionists sought through their works to express and evoke the primal emotions that they found exemplified in archaic art.

In 1943, Adolph Gottlieb wrote:

A primitive expression reveals the constant awareness of powerful forces, the immediate presence of terror and fear, a recognition and acceptance of the brutality of the natural world as well as the eternal insecurity of life. That these feelings are being experienced by many people throughout the world today is an unfortunate fact, and to us an art that glosses over or erodes these feelings, is superficial and meaningless. That is why we insist on subject matter, a subject matter that embraces these feelings and permits them to be expressed.[12]

Gottlieb here expresses an assumption, consistent with Frazer, and shared also by the anthropologist Bronislaw Malinowski, that primitive people typically live in perpetual terror of both spiritual and natural forces over which they feel little control. Frazer and Malinowski both believed that the amelioration of this fear is a principal function of both magic and religion. Magic seeks to bend these forces to human needs and religion supplicates the deities for intervention. Both magic and religion function to salve feelings of fear, uncertainty, and impotence before terrifying forces. Frazer and Malinowski postulated the still widely accepted anthropological view that magic, religion, and myth function to salve uncertainty and to structure human experience, rendering the world as a meaningful cosmos.

For more than a century science and technology seemed to hold unlimited potential to reign in and subjugate the forces of nature, usurping the ancient functions of magic and religion as salves for human feelings of terror and impotence before nature. Gottlieb's statement reflects on the fact that, in the wake of the emergence of nuclear weaponry and the devastation of World War II, humanity now lives in constant fear and terror of its own technologies. Modern science and technology have thus established the conditions for a religious renascence. To be saved from its own powers, humanity again seeks solace in spirituality and religion.

In its efforts to stir all of the primal emotions to life, Abstract Expressionism seeks to evoke feelings of the "terror of the unknowable" as well as spiritual consolation. The movement is in sync with the Romantic assumption, as evinced by the aesthetic of the sublime, that spiritual feelings encompass both fear and consolation; in Burke's view, the sublime, by eliciting both terror before overwhelming forces and delight in the diminution of danger, both evokes and salves fear. As with the aesthetic of the sublime, the ideographs of Abstract Expressionism, as archetypal representations, seek to elicit feelings of both fear before numinous forces and spiritual consolation. They seek to tap into fear by their expressions of

the numinous, and elicit feelings of consolation by their symbolic resolution of conscious and unconscious, rational and non-rational, oppositions.

Abstract Expressionism developed three distinct types of ideographs: the gestural, "allover" works, with little structural differentiation, pictographic works in which a grid mediates abstract hieroglyphs, and color field works, consisting of more or less monochromatic planes. Exemplifying the gestural type, Pollock, for example, in his drip paintings, combines automatism with a process of rational mediation. Thus his drip method is automatist but the flow of paint is constantly mediated by conscious decisions. Surrealism also often entails a process of rational mediation, but at a later stage of production. In Pollock's drip paintings, automatism and rational mediation operate concurrently. Automatism allows primordial imagery to emerge from the unconscious mind while the artist's conscious decisions facilitate a rational integration of the unconscious content. Pollock's art, then, emerged through the dynamic interplay of conscious and unconscious activities. In Jungian terms, the resulting "chaotic order," symbolically integrating conscious and unconscious oppositions, is emblematic of the process of psychic integration.

Pollock's drip method also exemplifies Jung's concept of synchronicity. Synchronistic events are significant accidents which arise from the inexplicable activities of the collective unconscious. These events, according to Jung, "seem to be connected primarily with activated archetypal processes in the unconscious mind." From the Greek *syn*, together, and *chronos*, time, synchronicity refers to related events which occur at the same time. Jung observed that "coincidences" often occur which defy ordinary causal explanation, as, for example, "when an inwardly perceived event (dream, vision, premonition, etc.) is seen to have a correspondence in external reality," and in cases "of similar or identical thoughts, dreams, etc. occurring at the same time in different places."[13] These are synchronistic events. They may also be implicated when fortuitous situations arise at times when they are most needed. For Jung, the collective unconscious, as a domain in which miraculous forces are at play, is a domain of infinite creativity. In Pollock's method of dripping and waving paint, as in all gestural Abstract Expressionist art, and as in all art, for that matter, which implicates the method of automatism, the artist's suspension of rational control over the medium allows for the occurrence of significant accidents which are synchronistic expressions of the archetypal processes of the unconscious mind. For Abstract Expressionism,

then, relative to Surrealism, the implications of automatism are especially profound. The Surrealists conceived of automatism as a means of expressing the emotional content of the personal unconscious. For Abstract Expressionism, automatism is a means of expressing the archetypal content of the collective unconscious.

Gottlieb's pictographs, made between 1941 and 1952, frame hieroglyphs within grid structures. His hieroglyphic figures are derived principally from the arts of ancient Egypt, sub-Saharan Africa, Oceania, and Native America. Gottlieb believed with Jung that the art of these cultures, because they are pre-rational, are direct expressions of the archetypal content of the collective unconscious. His hieroglyphs consist principally of simplified eyes, faces, hands, human forms, animal forms, spirals, and circles. Eyes are an especially pervasive feature of his pictographs. Eyes are ancient symbols of enlightenment, omniscience, and divine power. Hands, which are symbols of blessing, providence, and supernatural power, also appear frequently. Gottlieb models the basic grid structure of his pictographs after various ancient forms of writing.

Gottlieb's grids, by conferring structure on the primal forms of his hieroglyphs, signify a conscious and rational integration of collective unconscious content. Like Pollock's "chaotic order," then, they are emblematic of the psychic integration of conscious and unconscious mental oppositions. By symbolizing a suspension or resolution of oppositions, as in Mondrian's grids, they thus bear some of the significance of the Romantic *Fensterbild* works. Gottlieb's pictographs, like Pollock's drip paintings, render the non-rational content of the collective unconscious as fundamentally ordered, not chaotic, although of an ineffable order beyond the pale of rational apprehension. The collective unconscious as it is represented by Abstract Expressionism, as an ordered cosmos, thus corresponds to the Neoplatonic conception of the cosmic mind or *nous*, which is thought to embody reason in its transcendent aspect. In the Neoplatonic scheme, the *nous*, constituted of the Ideas, is an "intelligible" cosmos of transcendent order.

An archetypal motif also appears in de Kooning's *Woman* paintings. Many of his images of women, with grotesque faces, fierce grins, and huge bodies and breasts have been criticized exoterically as misogynous. A closer analysis, in view of the Abstract Expressionists' interests in primordial images, suggests that these images may likely signify the wrathful aspect of the archetypal great mother. India's Kali, Greece's Medusa, and Mexico's Chicomecoatl are a few outstanding examples of

this ancient image. Just as male gods can be malevolent, so can female. In keeping with the Abstract Expressionists' efforts to create terrible and fearsome sublime images, as in the ancient and primitive art they admire, these images show the great mother in its dark, monstrous, mysterious, numinous form. Comely, charming, shapely female images, by contrast, do nothing to evoke terror or fear, and belong to the aesthetic of the beautiful.

By its efforts to evoke feelings of terror and awe in numinous imagery, Abstract Expressionism implicates the aesthetic of the sublime. As Burke observed, the experience of the sublime is evoked through attributes of obscurity, power, privation, vastness, and infinity. By seeking to evoke the sublime through completely abstract forms, Abstract Expressionism took on a problem not faced by Romanticism, which by way of figuration could exploit the fact that the attributes of the sublime are easily found in nature. Nevertheless, if Abstract Expressionism does in fact represent archetypes, which are numinous, it necessarily also represents the sublime by virtue of the fact that the numinous is intrinsically sublime. By representing archetypes in their abstract essence, then, Abstract Expressionism attempts a more direct expression of the sublime than is possible through figuration. According to the philosophical rationale for a non-figurative representation of essences first adumbrated by Mondrian and Kandinsky, the spiritual essences of things are obscured by virtue of their material embodiment. Abstract Expressionism dispenses with figuration in an effort to directly disclose the numinous in its essence. This being so, Abstract Expressionism is an extreme manifestation of Hegel's conception of "romantic art," in which the material embodiment of the absolute idea—the sensuous form of art—is overwhelmed by the idea. Hegel contrasted romantic art with "symbolic art," typified in his view by Indian religious art, in which the idea is overwhelmed by the sensuous form, and with "classical art," typified in his view by ancient Greek art, in which the idea and the sensuous form are in balance. Because the forms of much Abstract Expressionist art are abstracted entirely from material representation and have only ideational significance, Hegel would likely have regarded the movement as manifesting art's final historical stage before its complete dissolution (*Auflösung*) into the formlessness of the idea. Abstract Expressionism thus takes Hegel's conception of romantic art a step further than Romantic art itself.

By its signification of a numinous reality which evokes feelings of spiritual consolation as well as fear, and by conferring structure on archetypal content, all types of Abstract Expressionist ideographs take on

the ancient functions of religion and myth as means of resolving uncertainty and rendering the world as a meaningful cosmos. The Western world was sorely in need of such spiritual consolation in the wake of the World Wars and the nuclear proliferation of the postwar period. By its revelation of archetypes and of the numinous, Abstract Expressionism also takes on the ancient religious function of shamanism. As the priest, wizard, or conjurer of pre-modern societies, who gain their mystical power through journeys to the underworld in trances and dreams, a shaman reveals and bestows the power and the knowledge of gods and spirits. By the same token, Abstract Expressionism reveals the numinous content of the collective unconscious through its ideographic representations. Jung observed that, by its revelation of collective unconscious content, art assumes a shamanic role in both primitive and modern cultures. Calling this type of revelatory art "visionary art," Jung believed that it emerges in the modern world as a form of psychological compensation for an excess of consciousness and rationality, and functions to help restore equilibrium between conscious and unconscious processes.[14]

Despite its consistence with Jungian psychology, Abstract Expressionist art often falls short of its aspirations to psychological resonance. Some works are more successful than others. Among the least impressive are Newman's virtually lifeless color field "zip" paintings, which in form are barely distinguishable from Minimal art, and which, abstracted from the lofty ideas Newman invested in them, do not stand on their own as exceptional works. Newman was the New York School's most prolific and eloquent writer. From the late 1940s on, during his mature period, however, he made many mediocre paintings. Nevertheless, as a sculptor he produced *Broken Obelisk* (1963-67), one of the finest and most affecting New York School works, which through a most simple and ancient form signifies the conjunction and integration of the oppositions of earth and heaven, matter and spirit, consciousness and unconsciousness. His zip paintings seek the same meaning but appear as purportless vertical stripes over more or less monochromatic grounds.

The notion that Newman's paintings carry profound emotional significance was buttressed by Robert Rosenblum's article "The Abstract Sublime," in *Art News* in 1961. In the article, Rosenblum imaginatively describes Newman's zip paintings as "awesomely simple mysteries that evoke the primeval moment of creation" and as presenting "a void as terrifying, if exhilarating, as the arctic emptiness of the tundra."[15] They thus exemplify, in his view, the "Romantic experiences of awe, terror,

boundlessness, and divinity" which are elicited by the sublime.[16] More credibly, he also ascribes such qualities to the works of Pollock, Rothko, and Clyfford Still. Rosenblum's appraisal of Newman's works is widely accepted and is rarely challenged.[17] Newman's zip paintings, however, bear little relation to the "terror of the unknowable" unless they are regarded, like conceptual art, as documents of ideas. For an inkling of these ideas, a viewer must be referred to what the artist and others have said and written about them. Showing a dearth of formal subtlety, the paintings themselves disclose no substantive meaning. Among the color field works, some of Mark Rothko's mature pieces succeed best in evoking the numinous qualities that Rosenblum ascribes to Newman's work. Rothko's cloud-like rectangles, which seem to mysteriously float over more or less solid color grounds, signify the dynamic interplay of harmonized oppositions.

Many of Gottlieb's pictographs are beautiful and evocative, but compare poorly with authentic works of ancient or tribal art. Genuine primitive art is more compelling by virtue of the fact that its symbolism reflects authentic indigenous traditions of religion and mythology. Gottlieb, by contrast, imports and appropriates the symbols of primitive art to modern painting. The symbols are largely eviscerated in the process. Gottlieb's pictographs appear like feeble forms of simulation, almost like cartoon caricatures, compared with genuine primitive art. Many of the gestural and allover Abstract Expressionist works, such as those of Pollock, Franz Kline, Richard Pousette-Dart, and Mark Tobey, perhaps owing to their use of automatism, are more successful. These works testify to the efficacy of automatism as a means to visually manifest the creative processes of the unconscious mind.

With respect to its expressions of the sublime, Abstract Expressionism generally compares poorly with Romantic art. Perhaps Abstract Expressionism proved that the aesthetic of the sublime is best expressed by figuration. Many of the best Abstract Expressionist works are capable of eliciting feelings of mystery and amazement. But only the very finest, such as Pollock and Rothko's best works, reliably elicit the profound feelings which are readily evoked by the landscapes of the German Romantics and the Hudson River School. Images of nature's violence, power, stillness, silence, light, and darkness have an intrinsic capacity to elicit the "terror of the unknowable." Abstract works are seldom so affecting.

Abstract Expressionism possesses all of the ideal typical features of Romantic art, if figuration can be excluded as a necessary feature. Romantic features are less conspicuous but still evident in Surrealist art.

Like Romantic art, Surrealism seeks to overcome the disenchantment and the rationalization of modern life. The Surrealists, however, showed little explicit interest in the aesthetic of the sublime. Nevertheless, Surrealist imagery is sublime by virtue of being, as Breton said, "marvelous." "The marvelous," as something which arouses wonder and astonishment, is virtually synonymous with the sublime. Surrealism and Abstract Expressionism, like Romanticism, seek to give expression to the dimensions of profound feeling which tend to be stultified by modern rationalized life. Abstract Expressionism, which seeks to revitalize the numinous dimension of the collective unconscious, is more explicit than Surrealism about the spiritual nature of such feeling. The Freudian paradigm that Surrealism is identified with does not provide a conceptual framework for spiritual concerns. Freud dismissed the idea of divinity as an irrational hypostatization of parental authority. Nevertheless, the Surrealists, by their admiration of primitive mysticism, showed a more sympathetic disposition toward the concept of spirituality than did Freud. As the Surrealists stood, however, without a concept of transpersonal consciousness, they were left to vaguely assume that if the contents of the personal unconscious are tapped, primal feelings will be dredged to consciousness, and the problem of psychological repression will be resolved. The Abstract Expressionists, in contrast, had in Jungian theory the benefit of a paradigm which was much more consistent with and adequate to a quest to revitalize the numinous dimensions of psychological experience.

Both Surrealism and Abstract Expressionism, as forms of resistance to the disenchantment and the rationalization of life, like Romantic art, seek to achieve their aims principally through the transformation of consciousness. Despite its political interests and involvements, the Surrealist movement's principal means of social praxis is the transformation of consciousness. It seeks to elicit a psychological transformation by its release of the creative potential of the personal unconscious. Abstract Expressionism seeks to transform consciousness by awakening it to the archetypal content of the collective unconscious. The Surrealist and Abstract Expressionists' emphases on the priority of consciousness thus corresponds to the importance of *Bildung* for the German Romantics, who were concerned primarily with the cultivation of the human spirit.

By its dynamic integration of rational and extra-rational processes, Abstract Expressionism, like Romantic art, seeks to harmonize estranged oppositions. This "sentimental" urge is compromised in Surrealist art,

which does not attempt such an integration but overcompensates in its reaction against rationality by ostensibly asserting the primacy of irrationality and unconsciousness over rationality and consciousness. Surrealism in this respect diverges sharply from Freud, who sought to unearth unconscious content as part of the therapeutic process but regarded cases of the domination of the ego by unconscious impulses as pathological. In practice, however, despite Surrealism's ostensible aims, the rational mediation which is often involved in its art-making methods implicates rationality and consciousness in its products.

Both Surrealism and Abstract Expressionism evince an idealization of nature by their idealization of primal forms of consciousness. Both movements view the dynamics of the human mind as integral to the organic processes of nature. Both regard unconscious processes as the most primeval and profound processes of mind, processes which, to remedy the spiritual impoverishment of modern life, must be raised to consciousness. Because both movements view unconscious processes as natural processes, their restoration of contact with these processes constitutes a manner of overcoming the alienation of nature.

With respect to essentialism, Abstract Expressionism's language of archetypal images evinces a kind of essentialism. Jung's archetypes are not archetypes in the strict Platonic sense but do bear some resemblance to Platonic archetypes. Like the Platonic Ideas, Jung's archetypes are conceived as basic patterns of existence which are ideal and universal. Jung, however, while inspired by Neoplatonism with respect to his formulation of the concept of the archetype, did not conceive of archetypes in Neoplatonic terms as products of the creative demiurge or of the *nous*. He rather conceived of archetypes in psychological terms as basic structures of the human collective unconscious.

A kind of essentialism might be read into the Surrealists' use of dream imagery and biomorphism, but the Surrealists showed no ostensible interest in essentialism to speak of. Symbolism is known to have had some impact on the development of Surrealism, but this fact alone does not present adequate cause to project Symbolist motives on Surrealist art. The Surrealists' unconscious imagery would lend itself more readily to an essentialist interpretation if it were meant to signify some universal domain, but the Surrealists ascribe to it no such meaning. Surrealist imagery can be readily interpreted as forms of archetypal imagery in a Jungian sense, but only retrospectively. The Surrealists had no such deliberate intentions, but regarded their images as expressions of the personal unconscious only. It

seems reasonable to suppose that if Breton had the same early exposure to Jung's ideas as he had to Freud's, Surrealism might have embraced Jungian thought. Surrealism's attitudes toward primitive religiosity and its interests in the revitalization of primal forms of consciousness are more compatible with Jung than with Freud. Surrealism, however, because of its militant antipathy toward rationality, is inconsistent with Jung's insistence on the rational integration of unconscious life. By the same token, Surrealism's opposition to rationality is also at odds with Freud.

Both Surrealism and Abstract Expressionism seek an authentic experience of self and free subjectivity. Both movements seek human self-actualization in a psychological experience of the vitality of unconscious life. Both movements also assert the autonomy of the self by virtue of their nonconformist resistance to the modern world's stultification of authentic emotional and spiritual experience. Abstract Expressionism evinces an even stronger ideal of selfhood by its Jungian concept of psychic integration, which it views as a step toward "individuation"—the complete self-actualization of human individuality in its uniqueness. Both movements evince a Romantic notion of the artist as genius, and of the salvific function of artistic genius, by their conceptions of the artist as a revealer of higher truths. Again, Abstract Expressionism manifests this notion more clearly by its more explicit interests in the revelation of a numinous order of psychological experience.

# Chapter 4
## Pop Art and Postmodernism

The concept of postmodernism is as complex and multifaceted as that of Romanticism. To make matters worse, discussions of postmodernism are often shrouded in excessive jargon and obscure prose. Stripped to its essence, however, the term generally signifies the exhaustion of modernism. It therefore cannot be clarified without some understanding of what the term modernism means.

The principal features that distinguish modern from pre-modern Western societies are their advanced industries and sciences, relatively complex divisions of labor, relatively large middle economic classes, and decentralized political authority. In modernity, the gradual historical transition from the intimate and informal social relations of *Gemeinschaft* to the impersonal and rationalized relations of *Gesellschaft* is fully developed. The emergence of modernity was concurrent with the decline of the traditional power of aristocracies and religious institutions. The greater political and intellectual freedom of modern life permitted the efflorescence of relatively autonomous institutions of politics, science, and the arts. The Enlightenment, the French Revolution, and the Industrial Revolution set the stage for the growth of modern forms of social organization in Europe throughout the 19th century. The pace at which individual countries made the transition to modernity varied greatly.

Modernism is fundamentally an ideology of enthusiasm for the prospects of modernity. It is largely based in and grew from the Enlightenment's belief in reason as the principal agent of human progress. Traced further back, it is certainly to some extent a secular transposition of the Jewish and Christian millenarian faith in the eventual triumph of goodness on earth. Some quintessential manifestations of the modernist ideology emerged in post-revolutionary France in the ideas of the Marquis de Condorcet, Claude-Henri Saint-Simon, and Auguste Comte. In his 1794

*Sketch for a Historical Picture of the Process of the Human Mind,* Condorcet lays out his belief in the infinite perfection of the human race as an inexorable process of history. He presents ten historical stages culminating in the Revolution of 1789 and a general revolutionary period which ushers in equality among nations and classes and the intellectual, moral, and physical perfection of humanity. Saint-Simon coined the terms "postivism" and "positive philosophy," which are approbations of scientific methods and science for the study and improvement of society. Comte, a student of Saint-Simon, devised an evolutionary "law of three stages" by which humanity passes through "theological" and "metaphysical" stages to finally arrive at the highest "positive" stage in which human thought is based on scientific principles.

G.W.F. Hegel developed a variation of the modernist ideology of progress. His dialectical idealism conceptualizes history as a progressive manifestation of the self-consciousness of absolute Spirit in human consciousness. Because freedom is an essential attribute of Spirit, according to Hegel, social institutions, in turn, will progressively manifest freedom as history unfolds. Hegel believed that the culmination of the dialectic of history was imminent at his time. He provided the conceptual basis for the dialectical materialism of Karl Marx, who thought that freedom, as embodied by communism, will be the inevitable historical outcome of social struggle.

The modernist faith in progress is implicated in Hegel's philosophy of art, which asserts that the basic purpose of both art and philosophy is the expression of Spirit. In Hegel's view, material objects are by their nature unable to express Spirit in its full import. Art is therefore destined to eventually be transmuted into philosophy, which requires no corporeal object (apart from the philosopher) for its expression. In philosophy, according to Hegel, art will realize its most perfect expression.

Modernism in art often implicates a celebration of modern art's relative autonomy. It is generally undergirded by the notion that modern art should be free to pursue its own intrinsic interests, in contrast to traditional art which was largely subordinate to extrinsic interests such as those of state and church. The German Romantics, for example, who generally held that the expression and the revelation of spirit is the fundamental purpose of art, hoped that Romantic art, by virtue of its freedom from the constraints of traditional religious canon, would provide the basis for a truly authentic spiritual experience. In this sense, Romanticism evinces the modernist celebration of both cultural autonomy and progress.

Abstract art was largely conceived from the beliefs of Mondrian and Kandinsky, consistent with the modernist valuation of artistic autonomy, and congruent also with Hegel's belief that material things obfuscate spiritual expression, that figurative representation itself is a form of extrinsic constraint on spiritual representation in art, and that art must free itself from this constraint. Both artists held a strong modernist faith in the historical progress of art and its role in actualizing human spiritual potential.

Defending abstract art from a purely formalist standpoint, the American critic Clement Greenberg held that modern art since Manet tends progressively toward the assertion of the picture surface and the art media. Greenberg thought that modern art's development culminated in American Abstract Expressionism, which by virtue of being abstract asserts the art object alone, as opposed to figurative art which is constrained by external points of reference.

The modernist faith in the progressive self-actualization of human life and culture was undermined during the 20$^{th}$ century by a series of great calamities such as the World Wars, the rise of fascism in Europe, the Holocaust, the degeneration of the Russian Revolution into the Soviet dictatorship, and the proliferation of weapons of mass destruction. It was also severely discredited by less dramatic but still profound developments in the West such as the persistence of widespread poverty, inequitable concentrations of wealth, the political complacency of the middle classes, the industrial devastation of nature, and the pernicious moral, intellectual, and aesthetic consequences of a socially pervasive ideology of economic consumption and the explosion of the commercial mass media.

In postmodernism, the modernist creed has collapsed. The French social critic Jean-François Lyotard's description of postmodernism as "incredulity toward metanarratives" has received much attention and approbation.[1] The metanarratives Lyotard refers to are conceptions of history as a coherent and meaningful process. The great stories by which modernism has made sense of history, such as those described above, are metanarratives. In Lyotard's postmodernist view, these metanarratives are intellectual constructions with no objective validity. In his view, history is in fact capricious and without coherent structure or ultimate purpose. Lyotard's epistemological nihilism extends to his evaluations of philosophical and scientific quests for truth and knowledge. These are also vain, in his view, and without universal validity. "Incredulity toward metanarratives" is a general characteristic of postmodernist thought.

Evidence of an nascent postmodernist attitude in art appeared in the late 19th century in the works of Edvard Munch. While Munch's works, through the 1890s, evince disillusionment and despair, they also express frustrated desire and longing. Munch thus never completely acquiesced to pessimism. Munch's *Scream* (1893), for example, is a cry for deliverance. Munch's anticipation of the eventual triumph of socialist ideals, shown in his political views if not in his art, further demonstrated that he held out a spirit of hope for a better world. Shortly thereafter, the Dadaists, reacting against the wanton carnage of World War I, consistent with postmodernism, saw the course of modern history up to their time as senseless. Many Dadaists, however, had expectations for social salvation in a communist revolution. They, then, like Munch, cannot be rightly called postmodernists.

The works of the American artist Edward Hopper show clearer evidence of an emerging postmodernist attitude. Hopper's many urban scenes are characterized by a mood of loneliness and desolation. These urban scenes, which typically show little or no evidence of nature, challenge a prominent modernist notion, originally associated with Comptian positivism, which equates human progress with the technological mastery of nature.[2] Hopper's works show a social world in which human possibilities for authentic experience and substantive meaning are crushed beneath mammoth routinized and impersonal institutional and technological structures. They show the urban world, in which technology and the mastery of nature have reached a high point of development, as a world in which social atomization and alienation have also reached a historical zenith. Hopper's wooden and affectless denizens of the urban scene appear resigned to an aimless and dreary lot in life.

Like the German Romantics, Hopper often presents lone figures standing or sitting before windows. But unlike the Romantic *Fensterbild* scenes, in which intersecting panes suggest the Christian symbol of salvation, Hopper's scenes present no signs of hope, inside or outside. The dark mood of Hopper's stark rooms and bland figures is mirrored by the barren buildings or landscapes outside. A curious feature of Hopper's windows is that they seldom feature vertical panes, which were very common when Hopper worked and are still widely in use today. Avoiding any suggestion of hope, Hopper's frequent omission of vertical panes was perhaps an intentional evasion of implicit cruciform symbolism. Hopper shows a world where hope has collapsed along with the collapse of substantive meaning and values.

The general tenor of Hopper's work is continued in the work of Eric Fischl, but with a stress upon the moral implications of the contemporary collapse of meaning and belief. Fischl's roughly rendered realism also bears some resemblance to Hopper's. What Fischl seems to lack in technical virtuosity is compensated for by the richness and complexity of his narrative content. Many of Fischl's important works were produced during the "me decade" of the 1980s in which the United States government spent heavily and extravagantly, plunging the nation into great debt, in which AIDS became a worldwide epidemic, and in which the Cold War reached a climax.

Fischl's works are characterized by moral ambiguity, mirroring the moral confusion of contemporary life and challenging the viewer to make sense of what is going on. During the early 1980s, Fischl frequently focused on the morality of sex, a sphere of human activity in which the general moral ambiguities of the day are mirrored. In *Birthday Boy* (1983), for example, a boy of about 12 lies nude before the spread legs of a much older nude woman, his hand caressing her leg. The title suggests that the scene has something to do with the boy's birthday celebration, but he looks very bored. The boy's boredom could signify either his distaste for the situation or simply that he is inured by excessive celebration. An undraped picture window indicates no sense of shame or discretion. In *Daddy's Girl* (1984), a scene possibly of innocent family joviality is disrupted by the question of why the figures are nude. A cocktail glass sitting precariously on the edge of a plant box suggests that the man may be drunk.

Perhaps Fischl's most important work so far, and one which is likely to be remembered as a quintessential postmodern image, is *The Old Man's Boat and the Old Man's Dog* (1980). Three nude men and two women appear on the deck of a cabin cruiser on very rough seas. A Dalmation, or "fire dog," is also present and highlights the sense of danger. The situation is precarious, but no one seems concerned. One of the men appears to crawl toward another half-reclining man. A third man lies at the boat's side drinking. One of the women, clad only in a life jacket and a bikini bottom, sits at the edge of the other side of the boat holding a fishing rod between her toes, and a second woman, nude, lies supine. The scene could be the aftermath of an orgy, or just a nudists' party. The scene suggests the nihilistic and carefree mood of people for whom all substantive values have collapsed. The picture can be read as a prophetic metaphor of America in the 1980s. Materialism and hedonism were for many the order of the day, and America lived above its means, without much evident concern for the

future consequences. Meanwhile the nation was threatened by nuclear war, an epidemic of terminal sexually transmitted disease, and economic calamity. As Arthur Kroker and David Cook have observed, this painting, like may others by Fischl, "perfectly capture[s] the fun mood of America in ruins."[3]

The works of both Hopper and Fischl, like those of the Romantics, appear to deal with the problem of meaning in modern life. Evincing a postmodernist attitude, however, both artists appear completely resigned to the collapse of meaning, so they can posit no solutions.

A postmodernist disposition is highly developed in Pop art, which first emerged in the early 1950s in the works of British artists such as Richard Hamilton, Eduardo Paolozzi, and William Turnbull. These artists sought to overcome the barriers between high and mass culture and make art that would appeal to average people. To do so, they based subject matter on familiar mass cultural images such as those of advertising, comic strips, and Hollywood films. American Pop art began to emerge in the mid-1950s, reacting not only against high culture in general but also against the intellectual and mystical obscurity of Abstract Expressionism in particular, which was regarded as having little or nothing to do with the real world. The Pop artists wanted to make art with explicit relevance to the experiences and the events of everyday life.

Both sides of the political spectrum have attacked Pop art for its apparent affirmation and validation of consumerist values. Exemplifying the right, Hilton Kramer deplores Pop art for its conflation and reconciliation of high culture with kitsch advertising art, and thus blames the movement for initiating a deterioration of standards of aesthetic quality. From the left, Benjamin Buchloh attacks Pop art, especially Andy Warhol's work, for its apparent celebration of commodity fetishism and corporate power.

While much Pop art presents a surface appearance of celebrating consumer culture, mass culture, and modern life in general, and it is hard to deny that Pop art tends to lack the aesthetic subtlety and refinement of many earlier art genres, the movement is yet implicated in a substantive and far-reaching critique of postwar American life. As the United States was immersed in an unprecedented economic boom, Pop art exposed the decadence beneath the shining facades of American life. Unlike modernist-type social criticism, however, which typically posits some alternative or solution to its objects of criticism, such as the Enlightenment's assertion of reason against superstition, Romanticism's assertion of the aesthetic of the

sublime against the disenchantment of life, Symbolism's assertion of the neo-Platonic Idea against the modern loss of spiritual focus, or Marxism's assertion of revolutionary struggle against social inequality, Pop art typically posits nothing against its objects of criticism. In Pop art, the optimism that animated modernist social criticism has collapsed. Pop art's bleak outlook on the future was summed up by Warhol: "Now it seems like nobody has big hopes for the future. We all seem to think that it's going to be just like it is now, only worse."[4] By its implicit critique of the mechanical conformism of the modern masses, the superficiality of prevailing materialistic values, and the general banality of modern life, Pop art demonstrates an implicit Romantic critique of the rationalization of life. Offering no solutions, Pop art differs crucially from Romanticism by its surrender to these problems. Pop art thus shares some of the negative aspects of Romantic social criticism, but exhibits no Romantic idealism. For the Pop artists, as for postmodernist social criticism in general, all solutions appeared untenable.

Sidra Stich's *Made In U.S.A.: An Americanization in Modern Art, The 50s and 60s* presents an incisive exposition of the dimension of social criticism in Pop art. As she observes, one of Pop art's earliest subjects was the American flag, which signified the conformism and complacency of postwar American middle-class life. Jasper Johns early flag paintings, made in the mid-1950s, in which painterly strokes are subdued by the flag pattern, as Stich observes, "convey a sense of conformity, as if creativity and individuality will have been sublimated or forced to comply with a prescribed norm."[5] Burgeoning metropolises were a measure of postwar American wealth and progress. Pop art often focuses on the darker side of the urban scene, calling attention to urban blight as well as the mindless conformism of middle class life. In Claes Oldenburg's various flag works, for example, as Stich writes, "the gritty, decaying atmosphere of urban slums is captured....This is a flag neither silken nor richly colored but fabricated out of debris and the scraps of American affluence."[6]

Johns later turned to another emblem of America, the map of the contiguous U.S. States. In John's map paintings of the early 1960s, in which painterly strokes partly obscure State borders, Stich observes, "the image of the U.S. is simultaneously affirmed and denied. There is a sense that a system and rigor once existed...[which has] fallen into a state of chaotic disarray."[7] In *George Washington* (1962), Roy Lichtenstein subverts and trivializes another national emblem, Gilbert Stuart's famous image of the first U.S. president, by presenting it as a comic strip

caricature.

In the early 1960s, for many people John Kennedy symbolized renewed national vigor. In *President Elect* (1961), in which the smiling Kennedy is juxtaposed with images of a shiny car and an ad for cake mix, James Rosenquist looks at the president in the context of America's burgeoning advertising culture, which emphasizes the importance of appearance over content and which, through the expanding influence of the mass media, was developing ever greater psychological power over a credulous mass population of consumers. As Stich observes, "With all the media hype, the presidency came to seem like a public relations spectacle, with the chief executive being marketed as a packaged product rather than an individual elected because of his character and political platform."[8]

In stark contrast to the Hudson River School's idyllic representations of the American landscape, Pop art shows the manufactured landscape of postwar America, a landscape lined with highways and spotted with commercial messages. Allan D'Arcangelo's *Full Moon* (1962) and *U.S. Highway* (1963), for example, as Stich observes, show the American road as "little more than a conveyor belt that runs through a repetitive, vacuous, monotonous environment,"[9] and expose

> the triumph of the synthetic over the natural. Here nature is overwhelmed by an immense advertising logo.... [A]dvertising is the lodestar for the new American explorer....Signs, not people, populate the landscape, and the vegetation appears as a blackened, vapid mass.[10]

Mass produced and mass processed foods, "fast foods" often eaten on the run like hot dogs, hamburgers, popsicles, soda pop, breakfast cereals, and canned foods, as emblems of postwar American mass economic consumption, were themes for Wayne Thiebaud, Claes Oldenburg, and Andy Warhol. As advertising, propagated by the mass media, became a ubiquitous feature of American culture, food was one of many everyday mass marketed items that often became associated as much or more with its advertising image and packaging than with package contents. Products acquired their own personae through advertising's continual repetition of labels, logos, and slogans. Thus Warhol's many soup can works show rows of frontally displayed labeled cans, not the food inside. These and other works such as Warhol's *Green Coca-Cola Bottles* (1962), reflect the mechanical conformism not just of mass produced products but also of the consumers of these products. Mirroring the pervasive conformism of the

postwar American middle classes, these products are characterized by sameness and uniformity. As Warhol observed, "Everybody looks alike and acts alike, and we're getting more and more that way."[11]

Such critical concerns may appear to be at odds with Warhol's ostensible attitudes and way of life. He seemed to many to be an inveterate devotee of money, glamour, and fame. Even at the socialite parties he constantly attended, however, Warhol's mood was typically one of ennui. As the *Newsweek* columnist Jack Kroll quotes the artist on his own self-impressions, "Looking into a mirror, [Warhol] saw 'the affectless gaze...the bored languor...the glamour rooted in despair...the pale, soft-spoken magical presence...the shadowy, voyeuristic, vaguely sinister aura...the albino-chalk skin...the shaggy silver-white hair...I'm everything my scrapbook says I am.'"[12] Far from a reveler, Warhol expressed a kind of *fin de siècle* cynicism and nihilism. As Kroll observes,

> Warhol noticed that the culture was an affair of mass-produced images that hurtled in squads and battalions at a population of image consumers....[He] knew something instinctively about a modern culture whose secret agenda seems to be dehumanization.... "During the 60s, I think, people forgot what emotions were supposed to be....I want to be a machine," said Warhol, meaning if you can't beat them, join them.[13]

By the 1960s, the Coca-Cola logo had come into its own as a symbol of triumphant postwar American capitalism. Thus Coke became one of Pop art's favorite subjects. Sold in 115 countries by 1961, the soft drink also exemplified the exportation of the American way of life. In Robert Rauschenberg's *Coca-Cola Plan* (1958), as Stich observes, "within alterlike niches,...the bottles are apotheosized by their encasement between a pair of angelic (or imperialistic) bird wings above a golden sphere. In this universe of junk materials, Coke is an ironically honorific object."[14] Warhol's *Green Coca-Cola Bottles* (1962), as Stich comments, "with its bottle-after-bottle, row-after-row imagery...captures the essence of mechanical replication and monotony, the endless, multitudinous yield of American manufacturing."[15] H.C. Westerman's Coke bottle totems, such as *Pillar of Truth* (1962), lampoon the decadence of consumer culture while also parodying the alleged vain idealism of the Abstract Expressionists' primitive totemic imagery.

Richard Estes's later Photo Realism, as in *Food City* (1967), *Gordon's Gin* (1968), and *The Candy Store* (1969), took up Pop art's preoccupation with the pervasiveness of consumer culture. These storefront pictures, in

which advertising images reflect and refract off store windows, show the kaleidoscopic visual impact of ubiquitous urban advertising and illustrate America's obsession with commercial products.

Pop art reacted to the postwar explosion of the mass communications media as means of consciousness manipulation which propagate conformist ideologies and ersatz realities. Focusing on the television news industry, for example, in *Six O'Clock News* (1964), Edward Kienholz casts Mickey Mouse as a news anchorperson. In this work, as Stich explains, Kienholz

> brands the network evening news as a simplistic, frivolous "Mickey Mouse" operation conducted by a corporate puppet whose role is to entertain the viewers....[A]ll stations covered the same stories and offered the same shallow scripts, which were recited by the parrot announcers.[16]

In Edward Ruscha's *Flash* (1963), the word "Flash" in giant letters is emblazoned above a small inverted section of a Dick Tracy comic. As Stich observes, this work "ridicules the notion that newspapers are a site for serious discourse, suggesting instead that theatrical display and hyperbole are the essence of mass media communication."[17] Warhol's *A Boy For Meg* (1961) reproduces the cover page of a major tabloid, letting the newspaper testify to its own inanity.

Pop art also turned its critical attention to the mass media's role in the production and promotion of celebrities. The process of celebrity promotion tends to reduce personalities to salable images. Elvis Presley's early libidinous image, for example, offended the prudish moral sensibilities of many Americans in the 1950s. But Tom Parker's mass media promotion of the rock star successfully recast Elvis as a "good American boy." In the 1950s and early 1960s, the images of Marilyn Monroe and Elizabeth Taylor were also appropriated by the mass media for maximum sales potential. Thus in Warhol's *Triple Elvis* (1962), *Twenty-five Colored Marilyns* (1962), and *Blue Liz as Cleopatra* (1962), rows of repeated images of the media stars reveal the celebrity as a "fabricated product designed for media adulation,...whose entire being is derived from mass production systems," as Stich observes.[18] In Ray Johnson's *James Dean* (1957), a publicity photo of the actor is shown with Lucky Strike emblems affixed to his head like Mickey Mouse ears. As Stich writes, "The emblems are abrupt reminders that Dean the rebel was in fact a product of a grand commercial enterprise. Dean, the celebrity, like any commercial product, had been carefully fabricated, packaged, and promoted."[19] Once a celebrity image

has been established, advertisers seek to exploit them to promote other products. Thus James Rosenquist's *Untitled (Joan Crawford Says...)* (1964) illustrates the commercial potency of the celebrity endorsement.

Pop art showed concerns with the problem of violence in America and the mass media's effect on attitudes toward human suffering. Warhol's *White Car Crash 19 Times* (1963), *Electric Chair* (1963), *Red Race Riot* (1963), and *Atomic Bomb* (1965), which show repeated images of the horrible subjects, refer to the mass media's tendency to inure people to suffering and death through endless repetition. As Warhol remarked, "When you see a gruesome picture over and over again, it doesn't really have any effect."[20] With the tendencies of news stories and news programs, in the interests of advertising sales and ratings, to try to entertain as well as inform, the distinction between news and entertainment has become blurred. On TV, news programs have thus come to blend in with the network's daily fare of violent serials, such as police and war dramas, which people passively absorb for vicarious thrills.

Along with other artists, Warhol was commissioned to exhibit works at the New York State Pavilion at the 1964 New York World's Fair. Defiant, Warhol refused to be party to spreading the myth of "America the Beautiful" at the fair. By displaying his *Thirteen Most Wanted Men* (1964), consisting of greatly enlarged FBI mug shots, he chose rather to show that, as H. Rap Brown said, "Violence is as American as apple pie." Within a few days, at the order of Governor Nelson Rockefeller, this explicitly subversive display was covered over.[21]

The Pop artists sought to overcome the social irrelevance and otherworldliness of much modern art by dealing clearly and directly with familiar conditions of everyday life. As inter-racial strife and the American involvement in Vietnam escalated in the 1960s, Pop art's social concerns became even more imperative. Pop art's explicit political concerns are demonstrated in many works such as Warhol's *Red Race Riot* (1963) with repeated news photos of an attack on unarmed black demonstrators by Birmingham police, Robert Rauschenberg's *Kite* (1963) showing discordant images of troops beneath a U.S. military helicopter and a large American bald eagle, Joe Overstreet's *New Jemima* (1964) showing the pancake mammy wielding a blasting machine gun, D'Arcangelo's *U.S. 80 (In Memory of Mrs. Liuzzo)* (1965) showing a bullet-ridden and blood-spattered American highway, and Faith Ringold's *The Flag is Bleeding* (1967).

Pop art's concerns with U.S. military policy were already evident in the

late 1950s. H.C. Westerman's *Evil New War God* (1958), which shows a war god as a metal robot, and Kienholz's *O'er the Ramparts We Watched Fascinated* (1959), which shows a damaged Great Seal of the United States amid dismembered bodied and machines, respond to the dangers of nuclear proliferation. These works express dread of the prospect of the mass annihilation of humanity by its own technological inventions, a holocaust which would actualize the Frankenstein theme in a nightmarish form that even Mary Shelley could not have imagined.

By the mid-1960s, as the Vietnam War burgeoned out of control, Pop art's focus on the subject of military policy became more persistent. James Rosenquist's *F-111* (1965) shows the fighter bomber, which was developed for use in Vietnam but turned out to be a defective and useless military spending fiasco, juxtaposed with a mushroom cloud and other emblems of modern technology and excessive economic consumption. Both Rosenquist, as in this work, and Rauschenberg, as in *Kite* and other works, frequently appropriated the technique of montage which was developed by the Dadaists in the wake of World War I. The photomontages of the Dadaists juxtapose incongruous but thematically conjoined images which convey a feeling of senselessness and disarray. Both Rosenquist and Rauschenberg used the method effectively to reflect the political and moral disorder of the 1960s. Red Grooms unsubtle *The Patriots Parade* (1967) shows cartoon-like figures of President Johnson and other military commanders waving large American flags while stomping on children. Edward Kienholz, in *The Eleventh Hour Final* (1968), focuses on TV's role in the war. Commenting on the impersonal nature of televised warfare, this assemblage shows a TV screen mounted on a tombstone in an American livingroom. The TV displays a toll of the day's dead and wounded while a clock above indicates eleven o'clock. As Stich explains,

> In this living room, it is always the eleventh hour, the time of the late-night news and the metaphoric hour before doom. Television magnified the brutality of war, yet it also mediated the effect of death, translating slaughter into a viewing experience and a scorecard of contrived numbers. It was a remote, distorted impression of the war that reached the American public, an impression more in line with a Hollywood spectacle or a public relations campaign than with documentary news coverage.[22]

Pop art confronts various social conditions which are now often identified as distinctive of postmodernity. Its most prominent postmodern

theme is the pervasive spirit of consumerism in the postwar United States. Much of Pop art highlights the preeminent visual emblems of postwar consumer capitalism—mass produced commercial products, product packages and logos, and advertising images. These subjects demonstrate the consequences of capitalism in an advanced stage, a stage at which both high culture and mass culture are colonized and saturated by corporate signs. In this state of affairs, all other values are eclipsed by the principle of economic consumption, which for great numbers of people has become the be-all and the end-all of life. Pop art often seems to celebrate this condition. A deeper analysis shows Pop art to be a form of critical reflection on the degenerative effects of the ideology of consumer capitalism taken to excess, and on the capacity of this ideology to subordinate great masses of people to its exigencies. Pop art thus stands, ironically, in a critical relationship to the social conditions that it ostensibly affirms.

Pop art's interests in corporate advertising, product packaging, and Hollywood celebrities highlight the postmodern world's exaltation of surface impressions and images. By its interests in the effects of TV, movies, and tabloids, Pop art reflects on the pervasiveness of the mass media and its role as the propagator of these images. Along with corporate advertising, the mass entertainment industry's perpetual promotion of personality images and ever-changing fads and fashions fosters general social tendencies toward the valuation of surface appearance and style over substance and quality. In the postmodern world, concerns with the objective merit of things tend to take a backseat to concerns with appearance and style. Thus consumer purchasing decisions are often determined as much or more by advertising images, brand labels, and social status perceptions than objective considerations of quality. The prevailing emphasis on surface appearance also leads many people to both model themselves and evaluate others with reference to popular media images rather than deeper considerations of character and integrity.

A serious social consequence of the mass media's ideological power and pervasiveness is that it tends to undermine the influence of traditional agents of socialization such as family, friends, and teachers as major sources of mores and values. The mass media plays a growing role in modeling peoples' attitudes and perceptions, arrogating traditional processes of face-to-face social interaction. Thus the postmodern social world is, to a great degree, a projection of mass media images. This state of affairs has led the postmodern theorist Jean Baudrillard to believe that

social life is growing entirely "simulated"; social life has become a projection of simulated realities such as those which are propagated by the mass media. As Baudrillard remarks, "[S]ociety is perhaps in the process of putting an end to the social, of burying the social beneath a simulation of the social."[23] Once again, technology, in this case the technology of the mass media, has come to dominate its inventors.

Pop art's Romantic content is found in its negative social criticism. Its implicit critique of conformism, consumerism, advertising, the mass media, and the superficiality of the values propagated by advertising and the mass media protests against the final consequences of the disenchantment and the rationalization of the world. The conditions that Pop art criticizes are the social results of the eclipse of value rationality by instrumental rationality. The hegemonic values of consumer capitalism have led to a social world which is devoted above all to the practical principle of material accumulation as an end in itself, and pursuits of abstract values such as truth, moral goodness, and beauty are consigned more and more to marginality and irrelevance. In the postmodern world, the process of rationalization is virtually complete. As corporate power has grown more pervasive, people's everyday lives, both as workers and consumers, are increasingly subsumed to corporate economic exigencies. This process is bolstered by the ubiquitous mass media which constantly bombards its audience with commercial messages. The mass entertainment industry's emphasis on image, style, and the spectacle of raw sensations further undercuts substantive values, providing its audience with little incentive to transcend a shallow sense of life's purposes. The postmodern world thus reduces people more than ever to cogs in corporate and industrial wheels, while the dullness of life is for a great many people palliated mainly by the indulgence of consumer desires and the passive absorption of trivial mass media sensations. In the postmodern world, all other values recede before the principles of material consumption and corporate growth.

By positing nothing against the decadent social conditions that it criticizes, Pop art capitulates to these conditions, but not so completely that it has lost the sense of dissatisfaction which is essential to any social critique. Pop art's social criticism is evidence of a residue of the modernist longing for a better world. However, like postmodernist social criticism in general, Pop art can posit no alternatives because it is divested of the supposed naive idealism that animated modernist social criticism.

Pop art is distinguished from more extreme forms of postmodernist art by its critical tenor. More extreme forms are exemplified by works of Jeff

Koons and Kenny Scharf, as good examples, which appear to abdicate all values save crass sensationalism and the profit motive, and possess no critical significance except for the fact that their very presence in supposed high art institutions testifies to the decadent state of postmodernist culture in general and the aesthetic lacuna of art which is abstracted from all substantive values. The absence of beauty in this work is perhaps the outcome of its complete abstraction from value content. In this work, no trace is left of the ideals that animated modernist art.

It is perhaps on account of its vestige of value content that a remnant of beauty remains in some Pop art. The beautiful in art, even if abstracted from all social concerns, as in *l'art pour l'art*, mirrors an artist's capacity to envision perfection. The beauty in socially concerned art discloses at least some vestige of longing for a better world. On the other hand, beauty appears to be lost in art which completely abandons substantive values. As the ideals that animated modernist art have disintegrated, so has the beauty of art also withered away.

Eclecticism is one of the hallmarks of the present-day art scene. In the current climate, one style is as good as another, and anything goes. Eclecticism is one of the consequence of the breakdown of the modernist ideology of progress. In the modernist views of art, art followed a pattern of development on a historical trajectory toward the realization of some ideal of perfection. Now that the various modernist notions of progress have fallen by the wayside, eclecticism is the order of the day.

# Chapter 5
# Earthworks

Earthwork art, or art which is made from the natural materials of the land, is perhaps the most significant genre in which Romantic values have survived despite the emergence of postmodernism. Although earthworks come in all sizes, Romantic features are especially pronounced in large scale earthworks, such as those discussed in this chapter, principally by virtue of their manifestations of the aesthetic of the sublime.

Some of the most prominent large scale earthwork artists, such as Robert Smithson, Walter de Maria, and Robert Morris, also figured prominently in the Minimal art movement, which carried to a terminal point the elimination of ideational content and the assertion of the art object which was preached as a teleological doctrine by Clement Greenberg and his formalist disciples. Minimalism sought a complete abrogation of content and a totally self-referential art form, a goal which it achieved by its reduction of the formal elements of composition. Where differentiated form does appear in Minimal art, as in several early paintings by Frank Stella in which lines reiterate the canvas shape, it tends to serve the Minimalist urge toward self-referentiality. Although Minimalist art carried the assertion of the art object to an extreme, it was received badly by some formalist critics. In Clement Greenberg's judgement, for example, the subtle constituents of "quality" were lost in Minimalism's mechanical assertion of the art object.[1]

Although Minimalism achieves an abrogation of content by its negation of the elements of composition, the reduction of formal complexity in art does not as a rule militate against the disclosure of ideational content. Mondrian showed in his work, by his simplification of the elements of composition, that formal reductivism can be used as a means of amplifying ideational content. Formal reductivism is also a basic characteristic of the Abstract Expressionist works of Barnett Newman and Mark Rothko. John

Graham, who was largely responsible for the early dissemination of Jungian ideas to the fledgling Abstract Expressionists, claimed in 1939 to be the inventor of a technique he called "Minimalism." As he wrote in *Systems and Dialectics of Art*, "Minimalism is the reducing of painting to the minimum ingredients for the sake of discovering the ultimate, logical destination of painting in the process of abstracting...Founder: Graham."[2] Graham's concept of Minimalism extends the strategy of French Symbolist art, for which the process of formal simplification facilitates the shining forth of spiritual essences. In Symbolist art, simplified forms serve to disclose rather than negate ideational content. Accordingly, the Abstract Expressionist works of Newman and Rothko seek to disclose ideational content by their reduction of differentiated form, and show that minimal form can be used to facilitate ideational expression. Likewise, earthworks are characteristically minimal in form, but they are also typically rife with signification. In earthwork art, in which minimal forms disclose rather than negate content, the formal strategy of Minimalism is turned on its head. Exceptions exist, such as the earthworks of Carl Andre which, like his other Minimalist works, are meant to signify nothing other than themselves.

The earthwork genre emerged in late 1960s America, amidst a turbulent political climate in which many artists felt compelled to invest their work with substantive social relevance. Many artists during the late 1960s viewed conventional forms of painting and sculpture as too bound up with the economic interests of the art world and as detached from the meaningful concerns of social and political life. At the time, few people if any yet realized that the succession of major innovations of painting on canvas which had until then characterized modern art history were on the verge of exhaustion, and the art world stood eagerly poised to capitalize on the next new "ism." While the earthwork movement provided the art world with a new genre, it evaded the cupidity of the gallery system. The period gave rise to various other radical art genres, such as performance and Fluxus art, which, like earthworks, resist conventional modes of gallery presentation and express social and political concerns. Earthwork art challenged the tendencies of conventional art objects to lend themselves readily to commodification within the gallery system. Emulating the scale of ancient monuments, many earthworks are very large and are also site-specific, made exclusively for the natural sites that they occupy. Because of their size and their integration with the landscape, such earthworks cannot be sold except by the purchase of the land that they occupy, and

cannot be exhibited in galleries except as photographs.

The various protest and counter-cultural movements of the 1960s and early 1970s sought ecological awareness and spiritual consciousness expansion as well as minority rights and the end of the Vietnam War. The movements in various ways opposed the perceived oppressive and pernicious tendencies of established mores and institutions. Environmentalism gained popular support in the late 1960s, culminating on 22 April 1970 in the first Earth Day, which was the largest organized demonstration in U.S. history, involving an estimated 20 million citizens and thousands of schools and colleges. The event led to the creation of the Environmental Protection Agency and various legislation.

Environmentalism is an important part of the ideological foundation of earthwork art. Earthwork artists generally shared environmentalism's concerns with the objectification, exploitation, and alienation of nature. One of the movement's prominent Romantic features is its concern with the alienation of nature. Much of earthwork art evinces sentimental longing by its urge to overcome the breach between internal and external nature. Like Romantic art, much earthwork art seeks to evoke a vital sense of being connected to alienated natural processes. Smithson, for example, deliberately made his earthworks difficult to traverse so that, as one critic observed, "you become unusually aware of the physicality of your body in relation to its surroundings, of temperature, the movement of wind, the sounds of nature, and of how isolated you have been from nature until this moment."[3]

To evoke vital emotional responses to nature, another of earthwork art's prominent Romantic features is the aesthetic of the sublime. Because the sublime intimates an infinite reality which exceeds the scope of rational apprehension, it resists a sense of closure, or of a sense that beauty or truth has been finally reached, such as is exemplified in the formal order and harmonies of classical and neoclassical art. Because a sense of closure may tend to foster intellectual complacency and emotional torpor, resistance to closure is a necessary feature of any art which seeks to liberate thought or intensify emotions. Earthwork art further resists closure by its efforts to manifest an integration of art with the dynamic, organic processes of nature. In contrast to the relatively static, unchanging state of conventional art works, much earthwork art, in tandem with nature, participates in constant processes of physical change.

Intensifying their emotional resonance, many earthworks are composed of primal and very simple minimal forms such as spirals, mounds, and

vertical axes, which are also typical features of the religious and monumental art of ancient cultures. These forms may be construed as archetypal representations, but an empirical link to Platonic or Jungian archetypal theories cannot be definitely established in relation to early earthwork art. As a rule, earthwork artists were averse to concepts which seemed to them otherworldly and therefore removed from the substantive concerns of material life. However, references to the relevance of Gaston Bachelard's *The Poetics of Space* appear in some early discussions of earthwork art.[4] In the book, Bachelard reiterates the concept of the archetype, but couches the concept in terms which may appear scientific enough to be palatable to those who are averse to metaphysics. One of Bachelard's basic ideas is that certain "primal forms" resonate with "deep structures" of mind. This assumption is consistent with the Jungian notion that primal or archaic forms in art elicit profound psychological responses. As Jung supposed, archaic forms confer art works with significant meaning by virtue of their intrinsic psychological resonance. In ancient societies, these forms were associated with widely understood religious or mythological meanings. Much modern art, in contrast, often tends to be bewildering to the intellectually uninitiated. The conceptual sources of earthwork art's interests in archaic forms may not be possible to exactly determine. Nevertheless, it appears likely that many earthwork artists assumed, like the Abstract Expressionists, that archaic forms, by their resonance with a basic dimension of mind which is shared by all people, regardless of culture, class, or education, constitute a universal language, and are thus capable of rendering art meaningful to a broad spectrum of people. To adopt the use of archaic forms on the basis of this assumption would be consistent with the earthwork artists' general determination that art should be socially relevant.

Many modern people, especially city-dwellers, often seek a sense of communion with nature by visiting parks or wilderness areas, and many also seek a sense of connection with archaic cultures by visiting ancient monuments. By its situation in natural sites and its replication of the forms of ancient art, earthwork art responds to these needs. As Lucy Lippard observes, this kind of art, exhibited outdoors, is "more intimate and accessible, closer to peoples' lives, than art seen in brutally hierarchical buildings (museums look like courthouses, schools, or churches) or in elegant, exclusive settings (commercial galleries look like rich peoples' living rooms)."[5]

Robert Smithson was a pioneer of the earthwork genre, and exerted a

strong influence on other early earthwork artists. One of the most well known earthworks, and one which is an exemplar of the genre, is Smithson's *Spiral Jetty* (1970), a 1,500 foot long rock and salt crystal jetty built at a site at the Great Salt Lake in Utah which had been devastated by an unsuccessful attempt to extract oil. The jetty became submerged beneath the water in 1972, but reemerged in 1994 due to a falling water level, its stones totally covered with crystallized salt.

Smithson laid out an earthwork art theory in a 1973 article in *Artforum*, "Frederick Law Olmsted and the Dialectical Landscape." In the article, he explains that his own work is modeled after that of Olmsted, the prolific 19th century American landscape architect who designed New York's Central and Prospect parks among many other parks elsewhere. He describes Olmsted as "America's first Earthwork artist."[6] Olmsted found beauty in nature's intrinsic processes of regeneration and decay. He did not seek to force the landscape to comply with an idyllic design, a practice which was exemplified by the geometric and symmetrical patterns of traditional European landscape architecture, but tried to accentuate the landscape's own natural attributes. Smithson observes that Olmsted's construction of Central Park, in an area which was ravaged by waves of urban development, amounted to a mammoth "reclamation project." Following Olmsted's example, many of Smithson's projects also seek to "reclaim" sites which were devastated by industrial processes.

Smithson observes that Olmsted's "dialectical landscape" synthesizes the beautiful with the sublime; Olmsted's landscape designs physically manifest a triadic dialectic which is resolved in the "picturesque." The concepts of the beautiful and the sublime which constitute the thesis and the antithesis of Smithson's formula are derived from Edmund Burke's *A Philosophical Enquiry*. His synthetic concept of the picturesque originated in late 19th century British criticism in the context of an urge for renewed contact with nature and a reaction against the sterility of traditional approaches to landscape design. The essayists Uvedale Price, William Gilpin, and Richard Knight were principal advocates of the picturesque. They observed that rustic rural landscapes possess "picturesque" qualities of roughness, irregularity, and decay, qualities which the concepts of the sublime and the beautiful do not account for. As John Beardsley explains Price's concept of the picturesque, "Price felt that the sublime and the beautiful failed to account for those things that were crude, rustic, and irregular but that were visually engaging nevertheless. These he described as picturesque."[7] As Smithson also explains,

Inherent in the theories of Price and Gilpin, and in Olmsted's response to them, are the beginnings of a dialectic of the landscape. Burke's notion of "beautiful" and "sublime" functions as a *thesis* of smoothness, gentle curves, and delicacy of nature, and as an *antithesis* of terror, solitude, and vastness of nature, both of which are rooted in the real world, rather than in a Hegelian ideal. Price and Gilpin provide a *synthesis* with their formulation of the "picturesque," which is on close examination related to chance and change in the material order of nature.[8]

In Smithson's formula, the beautiful is embodied in those aspects of nature which are benevolent and regenerative, and the sublime is in those aspects which are malevolent and destructive. The picturesque, which reconciles these oppositions, is a synthetic quality which entails both regeneration and decay. As examples of the picturesque, Smithson cites a tree struck by lightning and a hill torn by floods, which are deformed or wrecked aspects of nature which can clearly be part of a landscape's beauty. Smithson observes that these aspects tend to increase in beauty through natural processes of reparation which occur through time. The picturesque thus emerges through the dynamic interplay of contradictory natural processes. Smithson's reclamation projects seek to activate these processes, facilitating the manifestation of the picturesque. For example, the *Spiral Jetty* promoted the growth of naturally occurring microorganisms which turned the water in and around the jetty various shades of pink, enhancing the visual splendor of the site.

Smithson stresses his opposition to "transcendentalist" dialectical notions, such as the dialectical idealism of Hegel, which, in his view, are escapist and without creative implications for the "real" world. For Smithson, dialectical processes are natural, and nature is a material thing. As Smithson writes,

The picturesque, far from being an inner movement of the mind, is based on real land; it precedes the mind in its material external existence. We cannot take a one-sided view of the landscape within this dialectic. A park can no longer be seen as "a thing in itself" but rather as a process of ongoing relationships existing in a physical region—the park becomes a "thing-for-us." As a result we are not hurled into the spiritualism of Thoreauian transcendentalism or its present day offspring of "modernist formalism" rooted in Kant, Hegel, and Fichte. Price, Gilpin, and Olmsted are forerunners of a dialectical materialism applied to the physical landscape. Dialectics of this type are a way of seeing things in a manifold of relations, not as isolated objects....Spiritualism widens the split between

man and nature.[9]

Smithson, then, seeks through his work to actively facilitate the actualization of dynamic material processes, and views idealistic concepts as useless and irrelevant. For its escapism Smithson also scorns "studio-based formalism and cubistic reductionism which would lead to our present day insipid notions of 'flatness' and 'lyrical abstraction'."[10] In his view, art should fulfill a practical function. In contrast with Romanticism, then, Smithson stresses the importance of direct physical action on the material environment over changes of consciousness.

Smithson's critique of "spiritualism" bears resemblance to Marx's critique of the political impotence of philosophical idealism, as expressed in *The German Ideology*. Along the same lines as Marx's critique of idealism, Smithson would likely have objected to the German Romantic concept of *Bildung* for its assumption that changes of the conditions of life must be based on changes of consciousness. Nevertheless, by his efforts to achieve emotional resonance through the aesthetic of the sublime and his use of archaic forms, Smithson, at least implicitly, shows some appreciation of the fact that art must appeal to psychological feelings.

Despite Smithson's aversion to idealism, his earthworks, and many of those of other earthwork artists as well, experienced first-hand, tend to evoke distinctively spiritual feelings and associations by virtue of their sublime qualities. Many earthworks, as in Romantic art, imbue nature with inspirational power. As Beardsley observes, Smithson's "grandly desolate sites—vast, empty, and somewhat malevolent,"[11] exemplify the aesthetic of the sublime. *Spiral Jetty*, for example, elicits experiences of vastness, solitude, and the imminence of the forces of nature.

The aesthetic of the sublime is also exemplified by Walter de Maria's *Lightning Field* (1974-1977), a construction of 400 vertical poles in a remote area of New Mexico which experiences frequent lightning storms. As Beardsley observes,

> [The] attributes of the sublime provide a virtual prescription for Walter de Maria's *Lightning Field*....He planned his work scrupulously to attract the lightning and thereby to celebrate its power and visual splendor....The work is neither of the earth nor of the sky but is of both; it is the means to an epiphany for those viewers susceptible to an awesome natural phenomenon. Few leave the *Lightning Field* untouched by the splendid desolation of its setting and the majesty of its purpose.[12]

Works such as these present the sublime as a natural force, as a property not of a disembodied spirit or God but of material nature itself. These works, in contrast with Romantic art, seek not only to symbolize the sublime, but to physically manifest the sublime. They seek not to elicit a revelation of the profundity of spirit, which in Smithson's view would be a vain indulgence of spiritual fantasy in which consciousness revels in its detachment from the world, but to reveal material nature as itself profound. By enveloping the viewer in their physical presence, and by their physical manifestations of the sublime, large scale earthworks overcome the traditional breach between the art work and the perceiving subject, and thus between art and life. They also overcome the breach between the spectator and nature. The spectator experiences the earthwork not as an external object, but stands within it, actively participating in its physical presence. In earthworks, nature is experienced as imminent, and the experience of the sublime is intensified by the imminence of nature.

The crop circles which have appeared in wheat and corn fields throughout England since the early 1980s should not be excluded from a consideration of earthworks, certainly not on the ad hominem grounds that some people believe that they are of non-human origin. As large scale site-specific art works which are composed of the natural materials of the land, crop circles correspond to a description of earthworks. Like many earthworks, crop circles are typically very susceptible to natural processes of change, and thus affirm these processes. Regardless of their origin, crop circles typically exemplify the sublime qualities of vastness, power, and obscurity, and have stirred the imaginations of people throughout the world. Investigating their causation, scientists have offered bizarre and unheard of meteorological explanations. The obscurity of their origin intensifies their awe-inspiring power; it is largely the basis of their emotional effect. As in some Abstract Expressionist works, their aura of profundity is accentuated by their presentation of patterns which resemble ancient hieroglyphs.

Earthwork art differs radically from Romantic art by its external form and its manner of presentation. It also differs by the general aversion of earthwork artists toward philosophical idealism. Nevertheless, it evinces many of Romantic art's principal features. By its efforts to evoke vital emotional responses to nature and integrate art with the processes of nature, earthwork art demonstrates both critical resistance to the disenchantment of life and sentimental longing to overcome the breach between humanity and nature. As a means toward stimulating vital

responses to nature, it evinces the aesthetic of the sublime. It manifests both essentialism and a Romantic idealization of antiquity by its presentations of archaic forms which, by virtue of their intrinsic psychological resonance, elicit profound feelings. It resists the rationalization of life not only by its opposition to the alienation of nature and the disenchantment of life but also by its opposition to the domination of art by market forces. By making art which evades traditional modes of exhibition and sale, it counters the processes by which art becomes just another commodity in a rationalized system of exchange.

The earthwork art genre emerged partly as a reaction against the elitism and the cupidity of the conventional gallery world.[13] While rural earthworks such as *Spiral Jetty* and *Lightning Field* circumvent the gallery system, however, their physical remoteness restricts their public accessibility. Remedying this problem, during the 1970s and 1980s, increased public funds have fostered earthworks in or near more populated areas. In 1973, Robert Morris gained support from the National Endowment for the Arts and other public sources for his *Grand Rapids Project*, which rehabilitated an eroded hillside in Grand Rapids, Michigan.[14] This earthwork and others by Morris, Herbert Bayer, and Michael Heizer have shown that enormous public support can be garnered for projects which serve practical public purposes.

In 1979, Morris was also selected to reclaim an abandoned 3.7 acre gravel pit on the outskirts of Seattle, Washington. Funded by the NEA and various local public sources, Morris transformed the desolate site into a grassy form which resembles a sunken amphitheater. Morris was concerned that reclamation projects might whitewash the effects of industrial devastation.[15] To prevent this, he left in place the stumps of razed trees which partly surround the site and which, while also exemplifying the "picturesque," are a reminder of the plunder that had occurred.

Bayer's *Mill Creek Canyon Earthworks* (1982), a reclamation project located in Kent, Washington's Colony Park, fulfilled both utilitarian and aesthetic purposes. Funded by many public and private sources, the work was conceived for the purpose of controlling floods caused by erosion and land development projects. It involved the construction of dams which were designed, in Bayer's words, "to give the dams a natural appearance conforming to the landscape and to become integral parts of the landscape being created."[16] Its completion was celebrated by a concert at the site by the Seattle Symphony Orchestra. The utility of the project clearly enhanced its broad support and public appeal.

Michael Heizer's *Effigy Tumuli Sculptures* (1983-1985), in Buffalo Rock, Illinois, reclaimed an area which had been devastated by strip mining. It consists of five huge earth mounds, or tumuli, shaped like animals Heizer thought would again thrive at the regenerated site. A "tumulus" is a human-made hill over a grave. As an archaic form which signifies transmigration, mounds function symbolically in earthwork art, representing processes of creative regeneration which the works themselves facilitate; these works bring nature back to life. The work was constructed in accordance with the Surface Mining Control and Reclamation Act of 1977, which mandates the restoration of strip mines, and was funded in large part by a surcharge on existing coal operations.[17]

Many artists have been attracted to public art for its capacity to involve large audiences in the reception of art, beyond the confines of the gallery world. The collaborative nature of public art, however, often constrains an artist's creative discretion. Many public art projects, such as those of Morris, Bayer, and Heizer, have shown that quality need not be sacrificed in the collaborative process. Nevertheless, intellectually challenging proposals are often passed over in favor of those that go down easy. As Beardsley observes, "There seems to be...something inimical in the practice of public art to the language of either transcendence or social criticism."[18] The situation has led many artists to avoid public art projects. To reap the wider audience of the public art genre, artists are often required to make unpleasant compromises.

# Chapter 6
# The Romantic Vision Today

Since the emergence of Pop art in the 1960s, as processes of rationalization have proceeded, Romantic attitudes have waned in the art world, where postmodernism has held wide sway. Romantic sentiments, however, have never vanished. Many artists today continue to deal with problems of disenchantment, alienation, authenticity, and meaning. Many also remain sanguine about art's capacities to revitalize spiritual feeling.

The paintings and collages of Beth Ames Swartz, often with luminescent colors and materials, present images and symbols from various Eastern and Western mystical traditions, expressing the artist's faith in the spiritually redemptive power of these traditions and of art. The paintings and sculptures of Ann McCoy, who is influenced by Jungian psychology, present figures from various ancient and pagan mythologies in surrealistic and symbol-laden scenarios. As a counterbalance to the patriarchal tendencies of Western cultures, she often depicts goddesses and various symbols of female fecundity. The paintings of Alex Grey, which have been reproduced by many periodicals including *Newsweek*, superpose accurate representations of the human anatomy with fantastic and intricate renderings of the spiritual or subtle body as the artist says he has envisioned it in spiritual ecstasies. Grey's figures, which correspond to conceptualizations of the subtle body in various Eastern and Western esoteric traditions, by uniting spiritual and material realities in single images, seek to overcome the dualistic tendencies in Western metaphysics to bifurcate the spiritual and material domains. The works of these artists, like those of many spiritually-oriented artists today, expressing a universalistic spirit, conflate the concepts of various cultural traditions in syncretistic efforts to demonstrate the essential unity of these traditions, and seek, according to the principles of anamnesis, to awaken spiritual responses through the unconscious resonance of their various archetypal

images.

Only a small minority of artists today have a spiritual focus. In a domain of contemporary culture as large as the art world, however, even a small percentage of artists constitute a very large number. The scope of this chapter is limited to just a few artists whose ideas or methods are strikingly innovative. The discussion focuses on the works of Anselm Kiefer, James Turrell, and Andy Goldsworthy.

## Anselm Kiefer

Anselm Kiefer participated in the revival of figurative expressionism which first emerged in Germany in the 1960s but which only began to receive significant international attention in the late 1970s. In the years immediately following World War II, figurative art was stigmatized by its association with the official art of both Soviet communism and German Nazism. Most German artists, seeking to avoid any association with Nazism, readily adopted the prevailing international abstract styles of Art Informel, French Tachisme, and American Abstract Expressionism, styles which became associated with the political independence and the cultural freedom of the war victors.[1] By the early 1960s, however, following the example the celebrated Fluxus, Anti-form, and Art Povera leader Joseph Beuys, artists such as Georg Bazelitz, Marcus Lupertz, A.R. Penck, Gerhard Richter, and later, Sigmar Polke and Kiefer, rejected the prevailing false conflation of freedom with abstraction and revived a figurative style similar to the German expressionist genres of the early 20th century, genres which the Nazis had banned and defined as "degenerate." Their figurative "neo-expressionism" thus resisted the cultural marginalization of postwar Germany, asserting the distinct character of indigenous German art against the homogenizing tendencies of the international styles. By reviving painterly styles, German neo-expressionism also resisted the tendencies of 1960s art toward high-tech or "cool" styles such as Pop and Minimal art which flattened out emotional expression. German neo-expressionism reasserts the emotional subjectivity of the artist.

Kiefer was influenced principally by Joseph Beuys, who was Kiefer's teacher at the Kunstakademie at Düsseldorf from 1970 to 1972. Beuys, who died in 1986, was of a mystical bent, a disciple of both Neoplatonism and the mystical doctrines of Rudolf Steiner. Declaring that "Every human being is an artist," Beuys sought to overcome the breach between art and everyday life and was committed to a didactic and socially transformative

role for art. He developed a cryptic symbolism, using unusual materials such as animal fat, felt, wax, and bones, which in order to comprehend requires knowledge of certain events of Beuys' own life as well as various metaphysical ideas.

While flying a mission over Russia as a Luftwaffe pilot during the winter of 1942-3, Beuys was shot down in Crimea. The crash left Beuys buried in snow and nearly dead. As the legend goes, he was rescued by Tartar tribesmen who for eight to twelve days, until he regained consciousness, covered him in animal fat and felt to keep him warm. Beuys' assemblages often refer to this event, which he treats as an allegory of the spiritual fall and regeneration of humanity in general. Following Steiner's eschatology, Beuys believed that the human spirit devolved from an essential state of divine perfection to which it will return by an incremental process of spiritual purification. He diagnosed humanity's present historical condition as overly rationalized or "cold" and "hard." In his view, the collective reawakening of humanity's inherent but dormant higher faculties of feeling and intuition will require the "warmth" of spirit. The experience of Nazism for Beuys epitomized the devolution of spiritual consciousness. Beuys recovered literally through the application of fat and felt in the Tartar's act of compassion. His use of fat and felt in his works alludes to the regenerative warmth of spirit. His works represent fat and felt as alchemical materials which work to transmute consciousness and to refine the human spirit.

Kiefer's symbolism is no less obscure than that of his mentor. As Mark Rosenthal observes in the Museum of Modern Art's 1987 Kiefer exhibition catalogue, "Kiefer expects his audience to be well versed in such areas as Norse myth, Wagnerian opera, Nazi war plans, theological and biblical history, and alchemy."[2] Visitors to the exhibit were offered, on admission, a glossary of 21 key terms and names such as "Kyffhausser," "Margarete and Shulamite," "Saturn Time," and "Yggdrasil." The specific meanings of these terms and their relations to Kiefer's work are covered elsewhere and need not be restated here. The particular elements of Kiefer's symbolism, in any event, are less pertinent to this discussion than the artist's general program, which is to confront the problem of meaning which emerged for German culture in the wake of the reign of Nazism and World War II. Kiefer's existential struggle for meaning and his interest in art as a heroic purveyor of meaning root him solidly in the German Romantic tradition.

An urge to salvage the integrity of Germany's cultural traditions, in spite of the disgraces of the Nazi era, undergirds Kiefer's work. He rejects

the notion that German traditions of mythology, religion, philosophy, and art constituted the cultural elements of a historical trajectory which culminated inexorably in authoritarianism and social ruin. His works thus counterpoise a prevalent postmodernist notion that representations of truth and quests for meaning are not only false but pernicious and oppressive.

Postmodernism's aversion toward certainties of any kind leads it only to endless aporias or doubts. Kiefer resists this epistemological nihilism, but not with the conviction of an exponent of traditional beliefs or of modernism. Kiefer takes the questions of postmodernism seriously. He challenges both the postmodernist equation of truth with oppression and the nihilism which is inherent in postmodernism's incredulity toward grand narratives. While he seeks to recover meaning from the ruins of the past, he never shows pretensions of certitude. Because his works resist a sense of closure, they accurately mirror the spirit of our time. Uncertainty is a pervasive fact of contemporary, or postmodern, life. Contemporary art which posits certainties resists or escapes but does not confront this fact. By virtue of his uncertainty, Kiefer engages directly with the epistemological problems of contemporary life.

The Nazi era had cast a pall of shame over the German national identity which, as Kiefer saw, could be lifted only by confronting the past. One of Kiefer's main concerns is whether some meaning might be salvaged from the devastation of the war.[3] In search of a historical theodicy, he explores whether the present can be redeemed in the face of the evils of history. His frequent references to major figures and events of German mythology and history signify his urge to come to terms with the past. His search leads him to confront the notion of human redemption through violent purge, an archetypal motif which dates back in Occidental mythology to the flood of *Genesis,* which is incorporated in the eschatological doctrines of Hegel and Marx, and which was also fundamental to the Nazi ideology. Hegel and Marx, both Germans, viewed the brutal events of history as necessary phases of an historical process which culminate in the eventual redemption of humanity in freedom. Kiefer's yearning for a redemptive logic is expressed in his frequent allusions to alchemy. His representations of fire and scorched landscapes or building interiors, often consisting of highly flammable materials such as dry wood or straw, and his frequent incorporation of molten metals in his works, refer to an alchemical process of refinement by fire. In Kiefer's works, this process is presented as always underway, but never actualized. His frequent use of emulsion, made of elements which resist combination, seems to emphasize the difficulty of the

alchemical process. By their constant states of irresolution, Kiefer's works scrupulously avoid any sense of closure. Kiefer constantly asks questions but presents no final answers.

Much of the critical discourse on the new German art has focused on whether or not the movement can credibly lay claim to substantive social relevance. A large body of literature has arisen, but the main positions of the debate are represented by Donald Kuspit, who defends the movement, and Benjamin Buchloh, who leads an attack against it.

Donald Kuspit's analyses of art are often constrained by their adherence to a Freudian psychodynamic paradigm. His analysis of German neo-expressionism, however, is insightful. He defends the movement on grounds that it gives vent to some repressed contents of German cultural history. From the standpoint of the German neo-expressionists, the international styles of the late 1940s and the 1950s tended to obscure the past by their urge toward an abstract "void" which seemed disassociated from indigenous traditions of German art and which, by their otherworldliness, also seemed oblivious to the concrete facts of life. For the new German artists, a revival of figuration seemed to be requisite to both recapturing a sense of continuity with pre-World War II German cultural traditions and achieving any meaningful reflection on the German past or present. Some critics have interpreted the movement as an attempt to revive German nationalism and have been outraged. For his frequent references to German history, German cultural "heroes," and Nazism, Kiefer is a frequent target of such charges.[4] In Kuspit's view, on the other hand, the German artistic revival of figuration and presentations of Germanic images are necessary to a process of overcoming the repression of cultural memory. He defends the movement on Freudian grounds that coming to terms with the past is contingent on becoming conscious of the past:

> The new German painters perform an extraordinary service for the German people. They lay to rest the ghosts—profound as only the monstrous can be—of German style, culture, and history, so that the people can be authentically new....They can be freed of a past identity by artistically reliving it.[5]

Buchloh observes alternating phases of criticality and non-criticality in modern art history.[6] He admires various early 20th century avant garde art movements, such as Russian Constructivism, Dadaism, and Surrealism,

which sought a major role for art in a process of revolutionary social transformation, and which in his view exemplify critical art. According to Buchloh, a formalistic and apolitical "new classicism" in modern art emerged after the beginning of World War I, as in Picasso's appropriative works which quoted from Ingres, and as in the works of many other artists such as Carlo Carra, André Derain, and Gino Severini, which turned away from social concerns. Buchloh interprets this classical revival as a manifestation of an authoritarian urge to fix an aesthetic orthodoxy, and orthodoxy which is concordant with bourgeois tendencies to reduce art to a market commodity and which exerts no tension with the social, political, and economic status quo.[7] He also dismisses German neo-expressionism as an exemplification of non-critical art, as a recycled form of high modernism which, by generating more gallery objects, is perfectly suited to established capitalist systems of art production and reception that reduce art to a commodity. In response to claims that by its invocation of memories of totalitarianism, the new German art functions as social criticism, he regards the ostensible political content of the movement as a red herring which diverts attention from the real economic and political problems of the present. In his view, the expressionistic revival exemplifies the submission of art to an erroneous sense of social impotence, or bad faith. Thus the new German art exemplifies the fact that the critical impulses of contemporary art are expressed in futile acts of heroic struggle which are abstracted from any kind of meaningful social engagement. He asserts that these acts manifest a melancholy regression to past forms of modernist art—forms which have proven to be impotent from a critical standpoint—and submission to the limitations of these forms. Whatever their ostensible critical content, then, in Buchloh's view, these forms, by their complete integration with established systems of production, reception, and exchange, are intrinsically debarred from playing any substantive role in a process of social transformation. He insists that contemporary artists should emulate the social vanguardism of their early 20th century forebears, without specifying what forms an effective vanguard art might now take or how the powerful integrative forces of the contemporary art market could be successfully circumvented.

Kuspit defends the new German art against Buchloh and also against similar attacks by other American critics such as Thomas Lawson, Douglas Crimp, Peter Schjeldahl, and Kim Levin. In his view, these critics are "traditionalists loyal to an old cause of modernism" who fail to acknowledge that the revolutionary strategies of modernist social

vanguardism are now exhausted.[8] As part of coming to terms with the reality of the exhaustion of these strategies, in Kuspit's view, artists and critics should now moderate their social ambitions. The new German art exemplifies realistic social expectations for art. While the movement acquiesces to reduced expectations, it nevertheless remains socially engaged by wrenching the repressed contents of German cultural memory to consciousness, a process which is critical to facing and coming to terms with a "bad dream of history."[9]

## James Turrel

Throughout his career, James Turrel's principal medium has been light. He began to exhibit his light projection pieces in the late 1960s, soon after his graduation from college, and continues to show new ones today. The main artistic influences on his work are Minimal art, earthwork art, the color field works of Mark Rothko, and the neon and flourescent light sculptures of Robert Irwin. Like earthworks, many of Turrel's pieces are site-specific. Minimal, they are also characterized by formal simplicity. His work is prefigured by the Luminist works of the Hudson River School of American Romantic painting, which aimed at symbolic representations of divinity by means of its subtle and nuanced depictions of natural light. Turrel owes much to Rothko for the latter artist's abstract and minimal transmutation of the aims of Luminism. Rothko's color field works sometimes seem to possess their own internal luminosity.

Turrell was raised in a Quaker family, and it seems likely that Quaker religious sensibilities have influenced his work. The Quaker religion is founded on the belief that God is alive in every person, and that one is led to both spiritual purity and righteous conduct through meditative contact with the spirit of God within. Spiritual purification, Quakers believe, also brings moral purification. Quakers conceive of God as "inner light." In their view, the religious experience is in essence an experience of light. God, for them, is realized by "following the light." They believe that the inner light must be experienced in quiet meditation, which requires patience and time. They reject Christian traditions of hierarchy, and have no priesthood of their own. In their view, religious knowledge must be a private discovery. They value silence and simplicity. In traditional Quaker meetings, members sit in quiet meditation, and speak only when they feel moved by the spirit of God. No member has more formal authority to speak than any other.

The main purpose of Turrell's light projection works is to evoke a direct and elemental experience of light. He seeks to achieve this by abstracting the viewer's experience of light from things extraneous to light. Seeking to direct the viewer's attention only to light itself, he typically hides his flourescent, halogen, and tungsten light sources from view. While the Luminists and Rothko depict light by means of paint, Turrel's light projection pieces present light by means of light itself, and thus present light as both the subject and the object of art. As Graig Adcock observes, "In Turrell's [works] what is expressed is the ineffability of the radiance itself...In these works, unlike those of any artist before him, light has become the art, rather than being the illumination revealing the art object..."[10] Made essentially of light, one of the least tangible substances, these works seem to strive toward immateriality.

When asked, Turrel typically discusses his work in the scientific terms of optical perception. His statements alone might lead one to believe that his principal interest is in the physical ways that the eye perceives light. While he vaguely acknowledges that "Light is often seen as the bearer of revelation,"[11] he has had little to say about the spiritual significance of his work. In light of his Quaker background, however, it would appear that he wants viewers, as in Quaker meditation, to arrive at their own individual experiences and associations, and is thus wary of projecting his own meanings. As he has commented, "You assemble the reality of the work. I set up this vehicle through which you discover the way you see."[12] He has described his works as "visual [Zen] koans," or conundrums, riddles without rational answers. As Adcock comments, Turrell is "working with non-verbal experience...and is content to leave it wordless."[13] Turrell's reticence about spiritual matters is, after all, consistent with the Quaker view that words tend to obfuscate the essence of spiritual truth, which is regarded as ineffable.

By the early 1970s, Turrel began to experiment with sky windows, or "skyspaces," which involve interactions of natural light with artificial light sources installed inside. Among his most important skyspaces are *Meeting* (1980-86), a permanent installation at P.S. 1 in Queens, New York, *Second Meeting* (1986), in Varese, Italy, and *Blue Blood* (1988), at the Center for Contemporary Art in Santa Fe, New Mexico. In these works, large geometric openings in room ceilings expose the outdoor sky. Colored tungsten lamps installed inside the rooms, hidden from view, provoke spectacular visual effects, causing the changing colors of the sky outside to seem amplified and intensified, especially during twilight, and also

change the interior color of the skyspace rooms. Like the German Romantic *Fensterbild* works, Turrel's skyspaces invite contemplation of the relations between the domains of the inner and the outer, of subjectivity and objectivity and, by their interactions of artificial and natural light, between human technology and nature. The natural light, the outdoor sky, and the passing clouds are integral parts of these works. By their integration of natural processes, they affirm these processes as part and parcel of the aesthetic experience. The beauty of the works suggests that the oppositions of subjectivity and objectivity, and of humanity and nature, can potentially be harmonized.

As Adcock observes of the skyspaces, "Their most dramatic revelations occur at the temporal boundaries between night and day."[14] Like much Romantic landscape art, Turrel's skyspaces celebrate twilight. In Romantic art, twilight, as the time of passage between the opposed times of day and night, is emblematic of spiritual transformation and the ineffable mysteries of the numinous. The skyspaces seem to bear the same symbolic meaning. As Turrell acknowleges, "What takes place while looking at the light in a skyspace is akin to wordless thought."[15] In the experience of the skyspaces, as in Quaker meditation, the spiritual fruits of contemplation are not realized instantly, but require some patience and time. To experience the works fully, a viewer must at least devote the time it takes for the sky, along with the interior of the skyspace room, to change colors perceptibly during twilight.

Since 1977, Turrel has been working on the *Roden Crater Project*, a monumental earthwork constructed from an extinct volcanic crater, the 600 foot high Roden Crater, in an Arizona volcanic mountain range located near the Grand Canyon and the Painted Desert. The landscape there is characterized by magnificent sunrises, sunsets, and clear and starry night skies. When it is finished, the shape of the crater bowl will be refined, making it more perfectly semi-hemispherical. The rim will also be conformed to a uniform height. This will produce an illusion of celestial vaulting. The perceived shape of the sky will mirror the shape of the crater bowl. From inside the reshaped bowl, the sky will appear to be an immense dome arching high overhead. The illusion will become more pronounced as the sky darkens. Due to the darkness of the crater bowl, the colors of the twilight and the night sky will also appear intensified, and the number of stars visible to the naked eye will be maximized. The illusion of celestial vaulting will be optimized from a supine position. Viewers will thus be provided with areas to lie down.

Turrell is being careful to avoid disrupting the natural environment in and around the crater. Reshaping the bowl will entail moving over 400 cubic yards of soil, but no soil will be removed. The project will also involve building a 1,035 foot tunnel through which visitors will walk to the crater floor and a series of chambers set at various optimal vantage points of celestial observation. After construction is finished, the area will be replanted with all its native vegetation. Apart from the tunnel and the chambers, it will not be readily apparent to visitors that the site had been altered.

The experience of the *Project* will be one of the earth and terrestrial nature as well as of the sky. Part of the experience will be the approach, which will entail navigating some fairly rough natural terrain. One will pass through the Ponderosa Pine Forest in the 20 mile drive from Sunset Crater. In the final approach on foot, the crater, which in profile resembles a stepped pyramid, will loom ever larger ahead. Once inside the bowl at twilight or at night, the remote setting and the intensified colors and celestial forms of the sky will likely evoke a keen sense of nature's imminence. Turrell has been criticized for making an earthwork which, because of its remote setting, will likely be accessible to few people. As the artist acknowledges, "Only a few people are likely to be there at any one time."[16] He feels, however, that the work will be best appreciated in conditions of relative isolation and solitude, conditions which are conducive to contemplation.

The *Roden Crater Project*, if it turns out successfully as conceived, will exemplify the sublime qualities of obscurity, power, privation, vastness, and infinity. The darkness of night and twilight manifest obscurity. The power of nature is evinced by the crater bowl itself, which was presumably once the site of exploding red-hot lava from deep within the earth, as well as by the magnificence of the dark and starry heavens. Privation is in the solitude, silence, and emptiness which are attributes of both the site and of the sky. Vastness and infinity are in the intrinsic breadth of both the volcanic mountain range and the sky above. The effects of the site will be intensified by the vivid colors of the sky. Turrell's presentations of intensified color, exemplified in his light projections pieces and his skyspaces as well as in the *Project*, recall the formal strategies of the French Symbolists, who believed that vivid colors are evocative of divine essences. The *Project* will implicate two prominent symbolic features of Romantic landscape art, namely the axis connecting earth and sky, manifested by the volcanic mountain itself, and twilight, with all of its own connotations of spiritual

transformation and mystery. Reiterating the axis, the *Project*'s illusory dome will also signify a link between the oppositions of earth and the heavens. As an expression of Romantic pantheism, or panentheism, in the *Project* both poles of the oppositions of earth and heaven, by virtue of their sublime qualities, are manifested as numinous, and thus as divine. The oppositions will be symbolically harmonized and conjoined by the sheer beauty of the experience of the *Project* as well as by the axes of the volcanic mound and the dome. Possibilities for the resolution of sentimental longing to overcome the alienation of nature will be intimated not only by the *Project*'s symbolic reconciliation of oppositions but also by the experience of the imminence of nature that the work will surely evoke.

### Andy Goldsworthy

Andy Goldsworthy, a Briton who resides in Scotland, makes earthworks of unusual delicacy. He finds common natural materials such as stones, pebbles, slate, ice, snow, earth, sand, dead branches, twigs, pine cones, leaves, flower petals, feathers, berries, and others, and arranges them in simple but subtly hued and sometimes brightly colored patterns and forms. His methods stand in stark contrast to those of many American earthwork artists such as Michael Heizer, Dennis Oppenheim, and Robert Morris, who have used bulldozers, trucks, and dynamite to construct their works. Goldsworthy uses only natural materials, and rarely uses tools. His works thus often appear more like strangely beautiful natural configurations than like human-made objects. His landscape pieces are site-specific. When working outdoors, he is careful that his works appear appropriate to and congruent with their settings.

Goldsworthy often improvises his pieces while on solitary excursions in the rural countryside. Because his pieces are often very ephemeral and sensitive to the vagaries of nature, he usually exhibits them only as photographs, although he also prepares occasional gallery installations. His works thus bear comparison to those of Richard Long, who makes often barely discernable alterations of the landscape while on long walks to remote places, and exhibits photographs of these alterations. Long's works are generally regarded as Conceptual art pieces because they principally signify and document extraneous events and ideas, namely Long's walks and his mood and demeanor while taking them. Long's pieces are generally bland and colorless, as if to ascertain that they will not divert attention from the concepts that they signify. Goldsworthy's pieces, in contrast, by

their striking forms and colors, are works of art in their own right, although they also document the artist's excursions.

In the tradition of Romanticism, Goldsworthy's pieces express reverence and respect for nature's processes and feelings of intimacy with nature. As relics of the artist's solitary communions with nature, they also seem to celebrate subjectivity. However, they show none of the complex symbolism or intense emotion of Romantic art. They do not manifest the aesthetic of the sublime. There is nothing grandiose or terrifying about them. On the contrary, they typically evince the qualities of delicacy and fragility that is associated with the aesthetic of the beautiful.

Goldsworthy's pieces tend to exemplify the classical Japanese aesthetic of *wabi-sabi*.[17] The artist has shown little special interest in Japanese culture, although he worked in Japan briefly in the late 1980s, well after he established his style. Presumably, then, his *wabi-sabi* aesthetic is coincidental. *Wabi-sabi* defies exact translation into English, but it connotes the beauty of things which are simple, inconspicuous, modest, subtle, imperfect, accidental, delicate, and impermanent. *Wabi-sabi* is an expression of reverence for nature, of acceptance of the vagaries of natural change, including processes of decay, and of attention to the present moment as opposed to the past or future. The development of the concept of *wabi-sabi* in Japan is traced to the influences of Taoism and Zen Buddhism. The *Wabi-sabi* aesthetic exemplifies the Taoist and Zen Buddhist ideals of reverence, humility, and acquiescence. It is an important part of the Japanese traditions of the ritual tea ceremony, flower arranging, and garden design.

While Goldsworthy's works evince a Romantic idealization of nature, they do not express the frustrated yearning to overcome the alienation of nature, or sentimental longing, which is a typical feature of Romantic art. They rather demonstrate a "naive" disposition of harmony with nature, as if to suggest that, for the artist, sentimental longing has been resolved, or that it was perhaps never a concern.

# Conclusion
## Can Art Re-enchant Life?

Can art effectively resist the rationalization of life? The most provocative responses to this question have come from the Frankfurt School of neo-Marxist thought which emerged in Germany in the 1920s. The basic concerns of the Frankfurt School are expressed in Max Horkheimer and Theodor Adorno's 1944 *Dialectic of Enlightenment*.[1] In the book, the authors describe a process of rationalization in the West, similar to that which was observed by Weber, by which instrumental reason has everywhere subsumed human life to a cold calculation of utility. In the wake of the evident failures of the optimistic historical prophecies of Hegel and Marx, the Frankfurt School critics speculated about whether cultural activities such as music and art could resist the oppressive effects of instrumental reason. They tended to be wary of expressions of idealism in music and art on grounds that such expressions tend to engender spurious impressions that social realities are reconciled with human ideals, fostering false consciousness and political complacency. Adorno's wariness toward any kind of pleasantness in music and art led him to advocate an aesthetic of discord. As a critic of music he reserved his highest praise for the atonal compositions of Arnold Schoenberg, which few apart from a faction of music experts have ever found tolerable. For its joyfulness or beauty, Adorno denounced jazz and much of classical music as decadent. In his view, discordant and cacophonous aesthetic forms most truthfully represent the grim realities of social life.

Horkheimer was more equivocal. Although he criticized much of modern culture for its escapism and complacency, and shared Adorno's partiality toward discordant aesthetic forms, he conceded that various forms of idealistic Western art since the 18th century have "preserved the utopia that evaporated from religion."[2] In the aftermath of the decline of faith in religious eschatologies, he believed that art could help preserve

human aspirations to eventually realize a better and freer world.

Horkheimer believed that religious yearning held the same potential. In a 1970 interview, he asserted that the millenarian ideals of the Jewish and Christian religious traditions, which express a "longing for the wholly other," must be preserved in secularized forms if Western people are to salvage any hopes of overcoming the oppressive conditions of modern life.[3] He sought to preserve the transcendent capacity of religious longing, its capacity to conceive of ideals of perfection which are "wholly other" than existing conditions. Such conceptions, as assertions of free subjectivity, are forms of resistance to the tyranny of reason. As Rudolf Siebert explains,

> Religion can be revolutionary (as longing) or reactionary (as certainty)....
> Horkheimer was more concerned with it [religious consciousness] as longing, as hope for something transcendent in the future. For Horkheimer, this longing can provide humanity with a consciousness of truth in the midst of the horrors of history....By secularizing religious hope, Horkheimer sought to preserve it in an increasingly secular world, even into a future, totally administered society.[4]

Horkheimer observed that the instrumentally rational institutions of modern life inhibit free subjectivity and the exercise of the imagination. People are everywhere encouraged to submit to their roles as functional cogs, and to aspire to little more of substance. They spend much of their leisure time consuming the tripe of the mass culture industries, which by and large merely echoes prevailing ideologies. As Horkheimer comments in *Eclipse of Reason*, "Modern mass culture...glorifies the world as it is. Motion pictures, the radio, popular biographies and novels have the same refrain: this is the rut...this is reality as it is and should be and will be."[5] Horkheimer also criticized the physical sciences, which are mainly disposed toward the technical domination of nature, and tend to constrain the scope of the imagination. As he wrote, "The hope that earthly horror does not possess the last word is, to be sure, a non-scientific wish."[6] He was ultimately unwilling to completely submit to the pessimistic narrative of *Dialectic of Enlightenment*, and turned to theology for a conceptual means to assert the freedom of the imagination against the rationalization of life.

Horkheimer never elaborated on the relevance of the "longing for the wholly other" to aesthetics, but the concept can easily be implicated in a critical sociology of art. In no form of modern secular culture has religious yearning been more evident than in art. With the exceptions of Pop art and the works of Hopper and Fischl, which are postmodernist forms of

pessimistic resignation, and Mondrian's abstract works, which are reconciled with rationalized processes, the various art forms discussed in this book have struggled to assert ideals of freedom against the disenchantment and the rationalization of life. These art forms express longings to throw off the fetters to the free life of the imagination.

Clearly, processes of rationalization in the West have never been significantly impeded by art. But the institution of art preserves a refuge where the human imagination can continue to express and communicate its hopes and ideals. If the art works discussed here accomplish little more, they at least give testimony and objective form to the ideal aspirations of spirit, and remain lasting sources of inspiration. While they are not very effective as social praxis, without them cultural life would surely be more bleak and miserable. Art which is bereft of ideals is deprived of the cosmos of hope for what might be possible, and by its nihilism fosters resignation to things as they are. Certainly, idealism and hopefulness are sources of inspiration and provide incentives to try to change life for the better.

The works discussed here are not expressions of complacency, but are forms of critical resistance to social forces of spiritual and psychological repression. The aesthetic of the sublime, which is implicated in Abstract Expressionism and earthwork art as well as in Romantic art, is an expression of sentimental longing to apprehend an ideal. It expresses a frustrated yearning to overcome alienation and harmonize the self with nature and spirit. As a representation of a numinous and ineffable order of spiritual infinitude, it always seems to evade complete apprehension. It does not represent a realized ideal, but forever reaches for an elusive goal which it cannot fully attain. The French Symbolists, who were disaffected by urban modernity and, like the Romantics, resisted the alienation of nature and sought to revitalize spiritual feeling, hardly endorsed the social status quo. Notwithstanding his aversion to material nature, Kandinsky sought to counterpoise spiritual values against prevalent restrictive materialistic ideologies. The Surrealists and the Abstract Expressionists resisted the modern oppression of the imagination and the unconscious life. In defiance of a pervasive nihilism, Kiefer seeks to salvage meaning from the rubble of history. Turrell's works evince a wish to reconnect to nature and the inner light. Even Goldsworthy's works, if they do not manifest frustrated yearning, are forms of contradiction to the alienation of nature. Far from complacent or satisfied, these art forms assert the implacable urges of the human spirit to overcome oppression and actualize its potential.

# Notes

## Introduction

1. Robert Rosenblum, *Modern Painting and the Northern Romantic Tradition: Friedrich to Rothko* (New York: Harper & Row, 1975).
2. Keith Hartley et al., eds., *The Romantic Spirit in German Art 1790-1990* (New York: Thames and Hudson, 1994).

## Chapter 1

1. Max Weber, *Economy and Society* (Berkeley: University of California Press, 1978), pp.19-22.
2. Ibid., pp.956-958.
3. Max Weber, *The Protestant Ethic and the Spirit of Capitalism* (New York: Scribner's, 1958 [1905]), p.182.
4. Friedrich Schiller, *On the Aesthetic Education of Man in a Series of Letters* (New York: Frederick Ungar, 1965 [1793]), p.40.
5. Ibid., p.26.
6. As translated in Frederick Beiser, *Enlightenment, Revolution, and Romanticism: The Genesis of Modern German Political Thought, 1790-1800* (Cambridge, Mass.: Harvard University Press, 1992), p.234.
7. Novalis, "Christianity or Europe," as translated in Frederick Beiser, *The Early Political Writings of the German Romantics* (New York: Cambridge University Press, 1996), p.70.
8. See Karl Kroeber, *Romantic Fantasy and Science Fiction* (New Haven, Conn.: Yale University Press, 1988), pp.9-30.
9. Lucien Levy-Bruhl, *How Natives Think* (Princeton, N.J.: Princeton University Press, 1985 [1910]).
10. Rosenblum, *Modern Painting and the Northern Romantic Tradition*, p.15.
11. Jean-Jacques Rousseau, *Émile* (New York: Basic Books, 1979 [1762]).
12. As translated in Lorenz Eitner, ed., *Neoclassicism and Romanticism: 1750-*

*1850* (New York: Harper & Row, 1989), p.206.

13. Edmund Burke, *A Philosophic Enquiry into the Origin of Our Ideas of the Sublime and the Beautiful* (New York: Oxford University Press, 1992 [1757]), p.36.

14. Ibid., p.47.

15. Ibid., p.53.

16. As translated in Mary Hurst Schubert, *Wilhelm Heinrich Wackenroder's Confessions and Fantasies* (University Park and London: Pennsylvania State University Press, 1971), pp.118, 119, 120 .

17. Friedrich Schiller, "Naive and Sentimental Poetry," in *Friedrich Schiller: Essays* (New York: Continuum, 1993 [1795]), p.195.

18. See Bernard Yack, *The Longing for Total Revolution: Philosophic Sources of Social Discontent from Rousseau to Marx and Nietzsche* (Berkeley: University of California Press, 1992), pp.133-184.

19. Schiller, "Naive and Sentimental Poetry," p.200.

20. See Beiser, *Enlightenment, Revolution, and Romanticism,* pp.227-232.

21. See ibid., pp.84-110; Yack, *The Longing for Total Revolution,* pp.133-184.

22. Schiller, *On the Aesthetic Education of Man,* p.26.

23. See Beiser, *Enlightenment, Revolution, and Romanticism,* pp.102-105.

24. See ibid., pp.245-260.

25. G.W.F. Hegel, *Early Theological Writings* (Philadelphia: University of Pennsylvania Press, 1971; See Yack, *The Longing for Total Revolution,* pp.188-203.

26. As translated in Tzvetan Todorov, *The Theory of the Symbol* (Ithaca, New York: Cornell University Press, 1984), p.198.

27. Novalis, *Henry von Ofterdingen* (Prospect Heights, Illinois: Waveland Press, 1990 [1802]), p.118.

28. Kathleen Raine, *Blake and the New Age* (London: George Allen & Unwin, 1979), pp.74-105.

29. See Werner Schmidt, "Nature and Reality," in Peter Betthausen et al., *The Romantic Spirit: German Drawings, 1750-1850, From the German Democratic Republic* (New York: Pierpont Morgan Library, 1988), pp.39-56.

30. Rosalind Krauss, *Grids: Format and Image in 20th Century Art* (New York: Pace Gallery, 1978).

31. As translated in Eitner, *Neoclassicism and Romanticism,* p.212.

32. Novalis, *Henry von Ofterdingen,* p.94.

33. Carl Jung, *Modern Man in Search of a Soul* (New York: Harcourt Brace Jovanovich, 1933), p.171.

Chapter 2

1. As translated in Herschel Chipp, ed., *Theories of Modern Art: A Source*

*Book by Artists and Critics* (Berkeley: University of California Press, 1968), p.48.

2. See Patricia Mathews, *Aurier: Symbolist Art Theory and Criticism* (University of North Carolina Press, 1984); Patricia Mathews, "Aurier and Van Gogh: Criticism and Response," in Kathleen Regier, ed., *The Spiritual Image in Modern Art* (Wheaton, Illinois: Theosophical Publishing House, 1987); For extensive discussions of the essentialist implications of the art of Gauguin, Mondrian, and Kandinsky, see Mark Cheetham, *The Rhetoric of Purity: Essentialist Theory and the Advent of Abstract Painting* (New York: Cambridge University Press, 1991); see also Mark Cheetham, "Mystical Memories: Gauguin's Neoplatonism and 'Abstraction' in Late-Nineteenth-Century Painting," *Art Journal* 46:1, Spring 1987, pp.15-21.

3. As translated in Sig Synnestvedt, *The Essential Swedenborg* (Swedenborg Foundation, 1970), p.142.

4. As translated in Chipp, *Theories of Modern Art*, p.90.

5. As translated in ibid., pp.93-94.

6. Novalis, "Christianity or Europe," as translated in Beiser, *The Early Political Writings of the German Romantics*, p.76.

7. As translated in Chipp, *Theories of Modern Art*, p.88.

8. As translated in Eitner, *Neoclassicism and Romanticism*, p.213.

9. As translated in ibid., p.211.

10. As translated in ibid., p.78.

11. Paul Gauguin, *The Writings of a Savage* (New York: Paragon House), p.139.

12. As translated in Chipp, *Theories of Modern Art*, p.90.

13. As translated in Cheetham, *The Rhetoric of Purity*, p.23.

14. For a discussion of the implications of anamnesis in Symbolist art theory, see ibid., pp.1-139.

15. Novalis, "Christianity or Europe," as translated in Beiser, *The Early Political Writings of the German Romantics*, p.63.

16. See Robert Edgerton, *Sick Societies: Challenging the Myth of Primitive Harmony* (New York: Free Press, 1992).

17. Many works by Picasso and other artists are sometimes loosely referred to as "romantic" for their expressive qualities, but expressiveness alone does not constitute a Romantic disposition. Picasso shows little or no interest either in invigorating profound spiritual feeling capacities or in overcoming the alienation of external nature, concerns which are basic to German and English Romanticism.

18. Annie Besant and C. W. Leadbeater, *Thought Forms* (New York: Quest, 1969 [1901]).

19. Mondrian, "Neo-Plasticism: The General Principle of Plastic Equivalence" and "Plastic Art and Pure Plastic Art," in Harry Holtzman and Martin James, eds., *The New Art—The New Life: The Collected Writings of Piet Mondrian* (New York: G. K. Hall, 1986).

20. See Mondrian, "Natural Reality and Abstract Reality," in Holtzman and

James, *The New Art—The New Life*.

21. Mondrian's concept of the tragic is discussed in many of his writings, but is cogently discussed in "The New Plastic in Painting," in Holtzman and James, *The New Art--The New Life*.

22. See ibid.

23. Mondrian, "Neo-Plasticism: The General Principle of Plastic Equivalence," in Holtzman and James, *The New Art—The New Life.*, p.137; Mondrian expresses similar sentiments in "Realist and Surrealist Art," in Holtzman and James, *The New Art—The New Life*, p.233. Mondrian probably refers to Fillippo Marinetti's "The Foundation and Manifesto of Futurism" of 1908: "We will glorify war--the only true hygiene of the world--militarism, patriotism, the destructive gesture of the anarchist, the beautiful Ideas which kill, and the scorn of woman." Reprinted in Chipp, *Theories of Modern Art*, p.286.

24. See Mondrian, "The New Plastic in Painting," and "Dialogue on the New Plastic," in Holtzman and James, *The New Art—The New Life*, pp.64-69 and p.77, respectively.

25. See Peg Weiss,"Kandinsky and the Symbolist Heritage," *Art Journal* 45:2, Summer 1985, pp.137-145.

26. See Wassily Kandinsky, "On the Problem of Form," as translated in Chipp, *Theories of Modern Art*, pp.155-170.

27. Wassily Kandinsky, *Concerning the Spiritual in Art* (New York: George Wittenborn, 1947 [1912]), p.33.

28. Kandinsky, "Two Directions," in Kenneth Lindsay and Peter Vergo, eds., *Kandinsky: Complete Writings on Art* (New York: Da Capo Press, 1982), p.779.

29. Kandinsky, *Concerning the Spiritual in Art*, p.26.

30. Kandinsky, "On the Problem of Form," as translated in Chipp, *Theories of Modern Art*, pp.156, 159.

31. The theme of oppositions was early evident in Kandinsky's works. The horse and rider motif of his Blue Rider period, for example, which is inspired by St. George, a warrior of Russian folk legend, signifies Kandinsky's efforts to reconcile reason with the unconscious. See Marit Werenskiold, "Kandinsky's Moscow," *Art in America* 77:3, March 1989, pp.96-111, and Marian Kester, "The Owl of Minerva" in Douglas Kellner, ed., *Passion and Rebellion: The Expressionist Heritage* (New York: Columbia University Press, 1983).

32. See Maurice Tushman and Judi Freeman, *The Spiritual in Art: Abstract Painting, 1890-1985* (New York: Abeville Press, 1986), p.202-205.

33. See Kandinsky, "Concrete Art," in Chipp, *Theories of Modern Art*, p.346-349.

34. As translated in Hartley et al., eds., *The Romantic Spirit in German Art*, pp.68-69.

35. As translated in Ibid., p.375.

36. As translated in Ibid., p.72.

Chapter 3

1. Novalis, *Henry on Ofterdingen*, p.19.

2. For a discussion of the influences of James Frazer and Lucien Levy-Bruhl upon Surrealist and Abstract Expressionist art, see Stephan Polcari, *Abstract Expressionism and the Modern Experience* (New York: Cambridge University Press, 1991), pp.21-40.

3. Levy-Bruhl, *How Natives Think*; Levy-Bruhl, *Primitive Mentality* (Boston: Beacon Press, 1966 [1922]).

4. André Breton, "What is Surrealism?," as translated in Chipp, *Theories of Modern Art*, pp.413-414.

5. John Graham, *Systems and Dialectics of Art* (Johns Hopkins University Press, 1971 [1937]).

6. For discussions of the influence of Carl Jung on the Abstract Expressionists, see Irving Sandler, *The Triumph of American Painting: A History of Abstract Expressionism* (New York: Harper & Row, 1970); Kirk Varnedoe, "Abstract Expressionism," in William Rubin, ed., *Primitivism in 20th Century Art* (New York: Museum of Modern Art, 1984, pp.615-659; W. Jackson Rushing, "Ritual and Myth: Native American Culture and Abstract Expressionism," in Tushman and Freeman, *The Spiritual in Art*; Stephan Polcari, *Abstract Expressionism and the Modern Experience*, pp.40-56.

7. Jung, *Collected Works*, Vol.9 (Princeton University Press), pp.79;48, Jung's italics.

8. Barnett Newman, *Barnett Newman: Selected Writings and Interviews* (New York: Alfred A. Knopf, 1990), p.107.

9. Ibid., p.108.

10. Ibid., pp.106-107.

11. Graham, *Systems and Dialectics of Art*, p.95.

12. As quoted in Clifford Ross, ed., *Abstract Expressionism: Creators and Critics* (New York: Harry Abrams, 1990), pp.211-212. The quote is from a script Gottlieb prepared for a radio broadcast titled "Art in New York," on WNYC on 13 October 1943.

13. Jung, *Memories, Dreams, Reflections* (New York: Random House, 1961), p.400.

14. Jung, *Modern Man in Search of a Soul*, pp.152-172.

15. Rosenblum, "The Abstract Sublime," *Art News* 59, February 1961, p.56.

16. Ibid., p.39.

17. For another critique of Rosenblum's assessment of Newman's work, see Michael Zakian, "Barnett Newman and the Sublime," *Arts* 62:6, February 1988, pp.33-39.

Chapter 4

1. Jean-François Lyotard, *The Postmodern Condition: A Report on Knowledge* (Minneapolis: University of Minnesota Press, 1979), p.xxiv.
2. Arthur Kroker and David Cook, *The Postmodern Scene: Excremental Culture and Hyper-Aesthetics* (New York: St. Martin's Press, 1986), pp.246; 251-252.
3. Ibid., p.280.
4. Andy Warhol, *America* (New York: Harper & Row, 1985), p.186.
5. Sidra Stich, *Made in U.S.A.: An Americanization in Modern Art, The 50s and 60s* (Berkeley: University of California Press, 1987), p.19.
6. Ibid., p.23-24.
7. Ibid., p.32.
8. Ibid., p.38.
9. Ibid., p.69.
10. Ibid., p.65.
11. As quoted in ibid., p.92.
12. Jack Kroll, "The Most Famous Artist," *Newsweek*, 9 March 1987.
13. Ibid.
14. Stich, *Made in U.S.A.*, p.96.
15. Ibid., p.92.
16. Ibid., p.120.
17. Ibid., p.117.
18. Ibid., p.131.
19. Ibid.
20. As quoted in ibid., p.173.
21. See ibid., p.176-177.
22. Ibid., p.199.
23. Jean Baudrillard, *In the Shadow of the Silent Majorities ...or, the End of the Social* (New York: Semiotext, 1983), p.67.

Chapter 5

1. See, for example, Clement Greenberg, "Recentness of Sculpture," in Gregory Battcock, ed., *Minimal Art: A Critical Anthology* (New York: Dutton, 1968); Clement Greenberg, "Modernist Painting," *Art and Literature* 4, Spring, 1965.
2. Graham, *System and Dialectics of Art*, pp.115-116.
3. John Coplans, "The 'Amarillo Ramp'," *Artforum* 12:8, April 1974, p.42.
4. Gaston Bachelard, *Poetics of Space* (New York: Orion Press, 1964). For references to the relevance of Bachelard to Land Art, see Nicolas Calas, "Documentizing," *Arts*, May 1970; Catherine Howett, "New Directions in Land Art," *Landscape Architecture*, January 1977, p.41.
5. Lucy Lippard, *Overlay: Contemporary Art and the Art of Prehistory* (New

York: Pantheon, 1983), pp.12-13.

6. Robert Smithson, "Frederick Law Olmsted and the Dialectical Landscape," Artforum 11:6, February 1973, p.65.

7. John Beardsley, *Earthworks and Beyond: Contemporary Art in the Landscape* (New York: Abbeville Press, 1989), p.63. See also John Beardsley, "Robert Smithson and the Dialectical Landscape," *Arts* 52 May 1978 and John Beardsley, "Traditional Aspects of New Land Art," *Art Journal*, Fall 1982.

8. Smithson, "Frederick Law Olmsted and the Dialectical Landscape," p.63.

9. Ibid, pp. 63, 65. Marxists have attacked Romanticism on the same grounds as Marx and Engels' critique of Hegel's idealism, as a vain and politically impotent form of spiritual escapism. For a recent example, see Jerome McGann, *The Romantic Ideology: A Critical Investigation* (University of Chicago Press, 1983). In *Romantic Ecology: Wordsworth and the Environmental Tradition* (London: Routledge, 1991), Jonathan Bate answers McGann, pointing out that English Romanticism in fact had palpable consequences for the "real" world. Bate shows that Wordsworth's poetry raised public consciousness about the importance of the preservation of nature and led to the emergence of environmentalism in 19th century Britain.

10. Smithson, "Frederick Law Olmsted and the Dialectical Landscape," p.64.

11. Beardsley, "Traditional Aspects of New Land Art," *Art Journal*, p.231.

12. Beardsley, *Earthworks and Beyond*, p.62.

13. See ibid., pp.13-39.

14. See ibid., pp.27,29.

15. See ibid., p.94.

16. As quoted in ibid., pp.94,97.

17. See ibid., pp.97-98.

18. Ibid, p.156.

Chapter 6

1. See Joseph Thompson, "Blasphemy on Our Side: Fates of the Figure in Postwar German Painting," in Thomas Krens et al., eds., *Refigured Painting: The German Image* (New York: Prestel, 1989).

2. Mark Rosenthal, *Anselm Kiefer* (Philadelphia Museum of Art, 1987), p.10.

3. See ibid., p.18.

4. See, for example, Jed Perl, "A Dissent on Kiefer," *New Criterion*, December 1988, pp.14-20, for an especially strong critique of Kiefer.

5. Donald Kuspit, "Flak from the 'Radicals': The American Case against Current German Painting," in Brian Wallis, *Art After Modernism: Rethinking Representation* (New York: New Museum of Contemporary Art, 1984), p.141.

6. See Benjamin Buchloh, "Figures of Authority, Ciphers of Regression," in Brian Wallis, *Art After Modernism*, pp.107-134.

7. Ibid., p.110-113.

8. Kuspit, "Flak from the 'Radicals': The American Case against Current German Painting," p.138.

9. Ibid., p.139.

10. Graig Adcock, *James Turrell: The Art of Light and Space* (Berkeley: University of California Press, 1990), pp.211, 227.

11. As quoted in ibid., p.227.

12. As quoted in ibid., p.216.

13. Ibid., p.227.

14. Ibid., p.124.

15. As quoted in ibid., p.125.

16. As quoted in ibid., p.199.

17. Leonard Koren, *Wabi-Sabi for Artists, Designers, Poets & Philosophers* (Berkeley: Stone Bridge Press, 1994).

Conclusion

1. Max Horkheimer and Theodor Adorno, *Dialectic of Enlightenment* (New York: Continuum, 1986 [1944]).

2. Max Horkheimer, *Critical Theory: Selected Essays* (New York: Continuum, 1992), p.275.

3. Max Horkheimer, "Auf das Andere Hoffen," an interview in *Der Spiegel*, 5 January 1970, pp.76-84; Rudolf Siebert, "Horkheimer's Sociology of Religion," *Telos* 30, Winter 1976-77, pp.127-143.

4. Siebert, "Horkheimer's Sociology of Religion," pp.131,135.

5. Horkheimer, *Eclipse of Reason* (New York: Continuum, 1974 [1947]), p.142.

6. Horkheimer, "Foreword," in Martin Jay, *The Dialectical Imagination: A History of the Frankfurt School and the Institute of Social Research, 1923-1950* (Boston: Little, Brown, 1973), p.xxi.

# Index